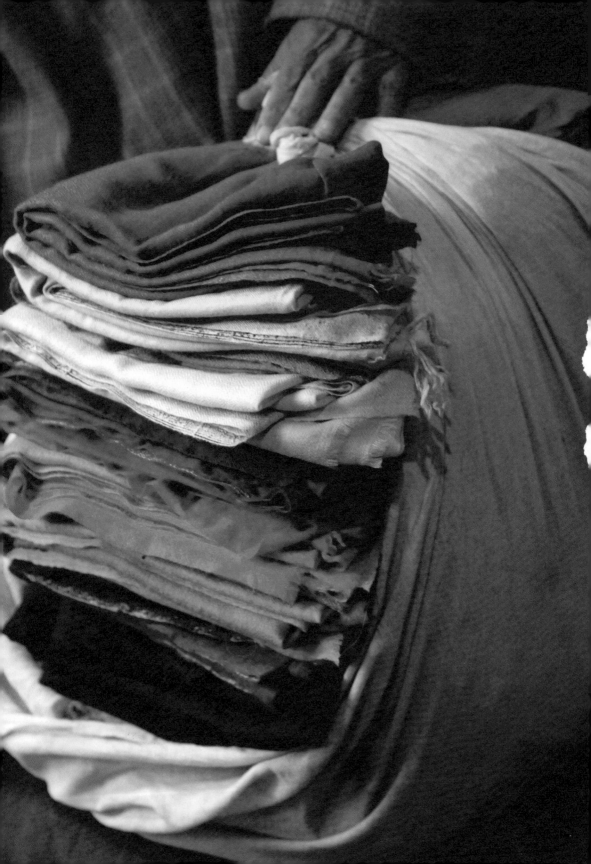

colour
a journey

words & photographs by
Victoria Alexander

MURDOCH BOOKS

Contents

We do not see colour
so much as intuit it.

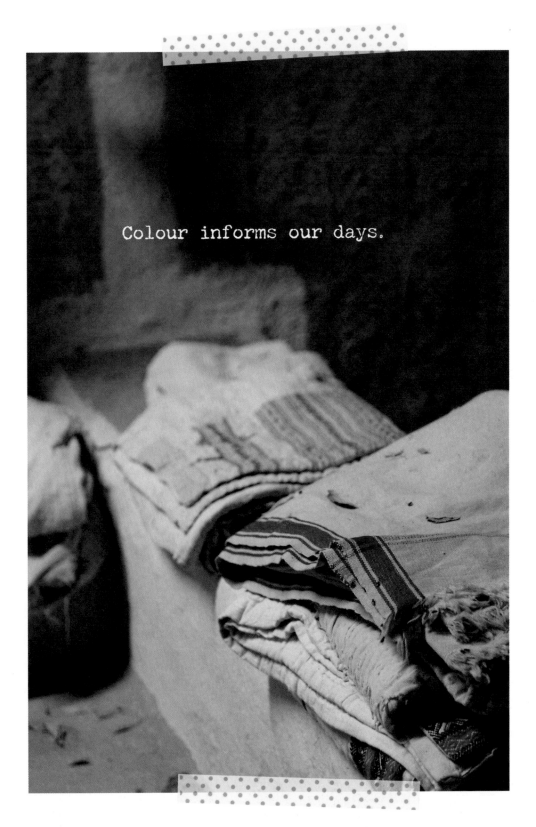

Colour informs our days.

What you see is what you feel

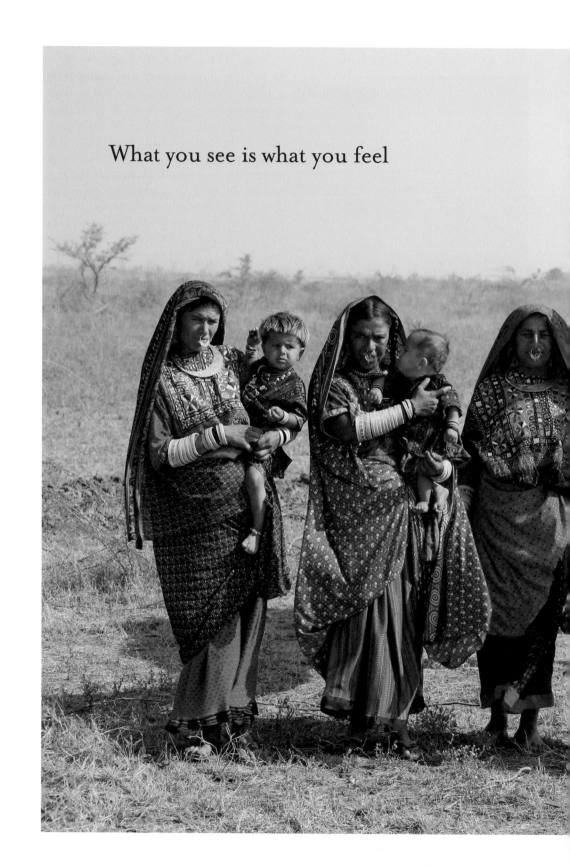

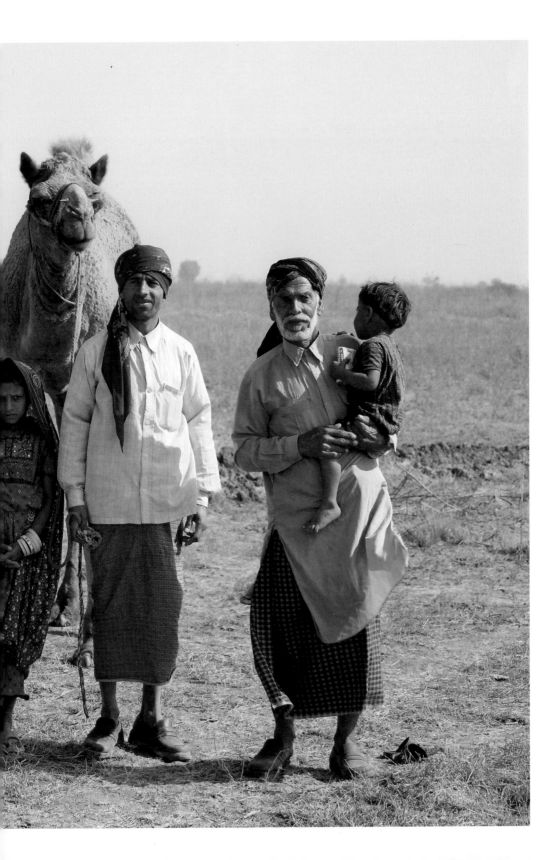

Ever since I first picked up a colouring pencil, I have been fascinated by colour and its harmonies, contrasts and discords. I remember all too well when my mother and father seemed huge and I small, feeling envious of other pupils who had boxes of multilayered colouring pencils. To me the layers represented options and opportunity. While some concentrated on using their pencils to carefully colour inside the line and felt remiss when they transgressed, I simply enjoyed the process. A friend says I have a rainbow brain— I suspect he's right. Colour in all its forms totally delights me.

Waxy pigments encased in wood come in all hues, soft or hard; they feel good to hold, tempt the imagination, offer up possibilities and are dream materials for filling in, feathering, blending, hatching and embossing. For most of us they represent some of our first lessons in colour, and teach us about choices.

I learnt more about just how stimulating colour can be when my mother decided to change our family home. I was about ten or so when she made a bold move from chic but faded camellia chintz in the softest of pinks and greens to a bright turquoise Marimekko watermelon print that invited you to sit. She added orange for discord. Much more than a colour change, this was a mood swing. What had been a quiet, calm room became instead a place that beckoned you in. Colour affects us emotionally and informs us intellectually.

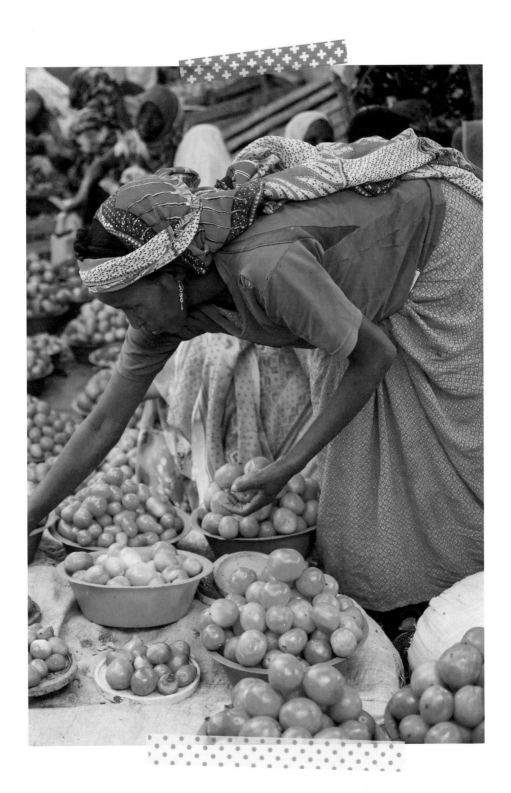

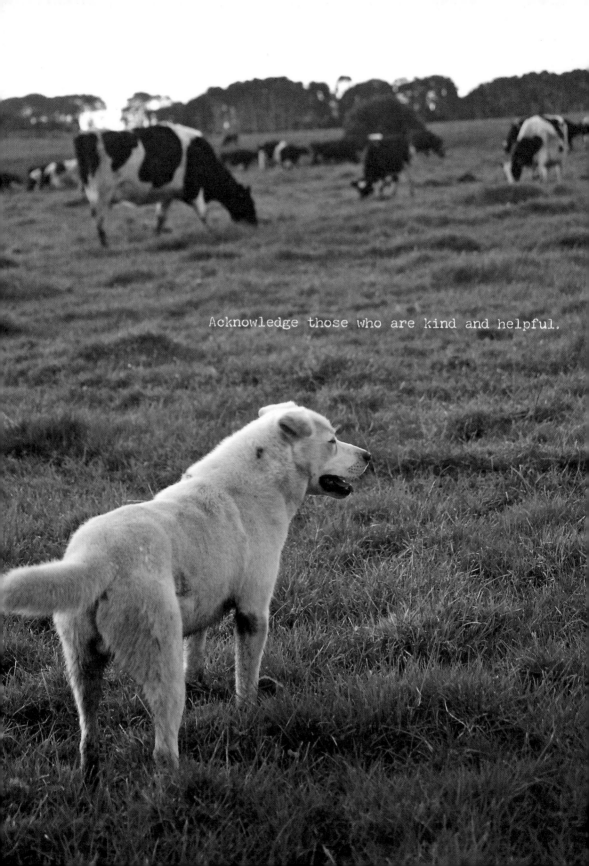

Acknowledge those who are kind and helpful.

My children learnt to spell with the aid of a different colour for each sound, and to add and subtract by using little coloured rods, each with a specific value. I hope others are doing so too.

The connections you make with colour during your childhood remain with you; colour retains memories. Stripped of its context and history, no colour actually means anything. It's a coded system, involving identity, ritual, religion and beauty, and varies from society to society.

Colour corresponds, communicates, tells us of the change of seasons, the ripening of foods, and about ourselves and others. Imagine these lush green fields parched and dry in varying shades of brown. No doubt the colour alone would prompt you to sympathise with the farmer for the hardship he was experiencing.

Colour links us with its unspoken language. We summarise ourselves with colour in our appearance and our homes yet, when we speak out loud to others about colour, we rarely add an adjective. In response to 'What's your favourite colour?', the answer may be blue, green or red perhaps. Yet there are countless greens, reds and blues. The language of colour is vast, visual and deserves a descriptor word or two to be fully understood—terms such as pea or cooking apple green, red wine or devilish red, aqua or deep indigo blue … sand, thunderclouds or wombat.

We prefer our food to be traditional in colour, expecting butter to be yellow, cherry-flavoured things to be red and milk white. Food colour affects our perception of flavour. Insidious chemicals added to food may make them visually attractive but they don't necessarily improve the taste, which also tends to be artificial. We should be very thankful to colour for guiding us in judging the ripeness of some foods. What a great job it does.

But it's the feeling certain colours evoke, such as feeling comforted, aroused or seduced by a colour or a combination of colours, and understanding and valuing that feeling that drives this book.

Colour is an important, sometimes subconscious, constant in our lives, one that enriches and informs us. I want to encourage you to embrace colour as an integral part of your life. To live, love and dye by colour, to know, and be known by, its tones. To use colour as a reminder that each moment is precious.

So there are reminders in this book, things such as 'Simplify your life' and 'Wherever you go there you are', as prompts to look again and see that the beauty and pleasures of life are all around you and that colour provides a means of being able to express yourself freely. They're not meant to be instructive—please see them as encouragements about daily choices and a way of being in the world. You may choose to read them as affirmations, but because there is beauty in the imperfect I prefer to think of them as colourful reminders of some of life's possibilities.

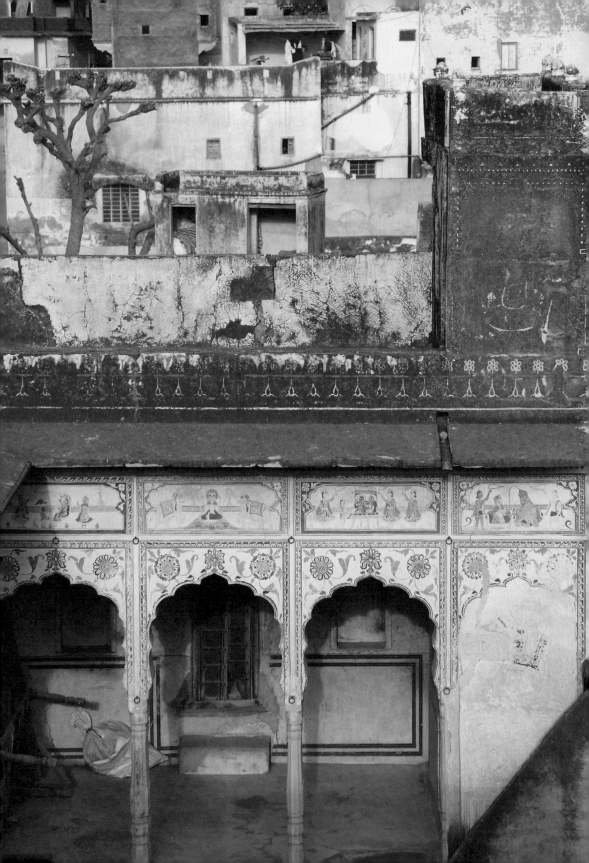

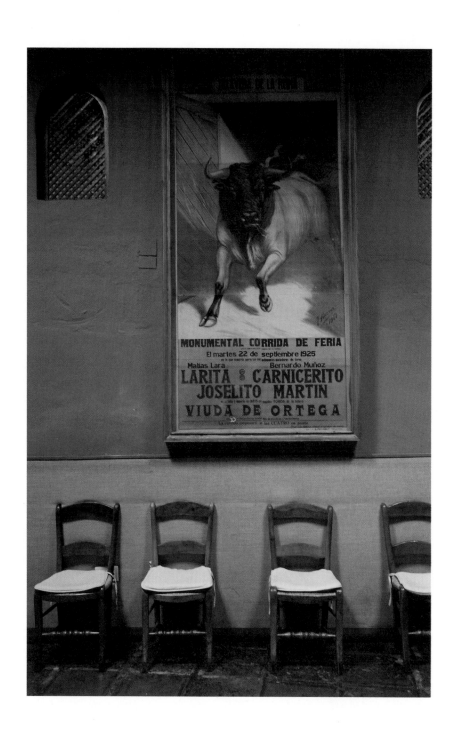

From red and white weddings to black and white funerals, colour speaks a language all its own. Put simply, colour is about *feeling*. We use it as a descriptor in colourful expressions such as 'green with envy', 'cool as a cucumber', 'a little white lie', 'feeling blue', 'sickly yellow', 'saw red' or 'black mood' to make our thoughts crystal clear.

It's not just babies who are stimulated by colour. We're all subconsciously affected by its hues; it has impact, and influences our mood and reactions. Did you know that 80 per cent of the information we receive comes from our eyes?

The colour effect goes like this: colour affects your mood and your mood affects your emotions, which in turn affect your decisions. Your moods are the underlying colouring through which you experience life. Although you are often unaware of where a good or bad, happy or sad one comes from, moods are none the less the subconscious state by which you colour and see your world. Moods are different from emotion, and colour has a direct and positive or negative effect on them. You can use colour to gauge or create a mood, a fluctuation or a difference. If you are in any doubt, just think of the many different emotional responses to a white flag of surrender. The mood you are in also influences the way your brain perceives, stores and recalls information.

There's much to be learnt in our search for pleasing combinations and contrasts. Both life and colour have a compelling richness; they can be sensual, dull or bright, pale or dark. Both can be harsh or kind, and involve tone, discord and harmony. Some are loud, others insignificant or distinctive. All are relative and relevant. There are times when they clash.

We all know people who feel safe wearing only a little colour, and some who make black their uniform. Yet colour can unite; it's fundamental to life and choice. Combining colours and finding the harmony in them is one of the most exciting and pleasurable aspects of being human. Without it there would be no art.

Colour is diverse, playing a role in religion, sacred stories and myths. It displays the unity of a cause and flies the flag of nations. It is an essential ingredient in the pursuit of beauty and, just as it is capable of camouflage, it also allows things to blush and bloom, to stand out and be counted.

The story of colour includes innovation, texture, profit and loss. The science and theory of colour is a vast subject, but one thing is clear—colour speaks all languages and also has a language all its own.

We interact with colour in a physiological way, gravitating towards our favourites, taking into account adjacent or opposite colours. Every colour produces a distinct impression, yet each colour we perceive is almost never as it really is in its purest form. Colour deceives.

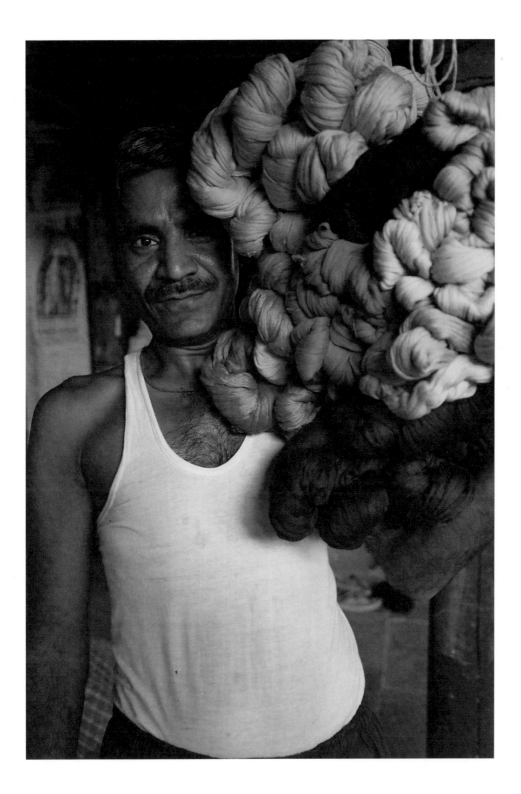

...e of a time when you responde...
...antly to a colour or natures artistry and
...made you feel good. You probably forgot
...else. There is a sense of freedom that
...es with letting go of your personal
...ry. We have little use for our past
...t to learn from it.

With our unique way of seeing, feeling and thinking, colour evokes innumerable readings. There are colours galore and endless combinations, shades and tones, but relatively few colour categories. When colour is used as a descriptor to a group, each person imagines a different tone based on their personal associations and reactions.

Colour subliminally affects our judgment. Imagine being in a meeting where everyone is wearing black, then in walks a late-comer, wearing orange. The reactions of everyone around the table will vary. Some will feel stimulated and intrigued to hear the guru's words, others will be sceptical, quietly thinking 'Why does he have to be so loud, I don't trust him', and all range of feelings in between, based solely on his choice of colour.

Colour continually surrounds us with its seemingly endless configurations and combinations, while colour theory has attracted the interest of some of history's most gifted intellectuals, including Aristotle, da Vinci, Newton, Goethe and Hegel.

In the seventeenth century, Sir Isaac Newton built his
scientific theory on physics, sunlight and certainty, while
Goethe's principle, devised in the eighteenth century,
relied on nature and knowing how to see and feel.
Whichever theory you believe, colour comes in varying
degrees of brilliance, just like us; it can be intense,
complementary and harmonious. It's the stuff of
dreams, and memories are enhanced by the use of it.

Different societies attach varying meanings and beliefs
to colour. Using colour, East can meet West, and old meet
new. Taste and colour go hand in hand, while honing your
eye for colour develops your powers of observation and
involves decisive decision-making.

Colour can show the passage of time and be used as a
reminder that joy and contentment are to be found in
the simplest of things.

Colour has the ability to give instantaneous, uncomplicated
pleasure, a prompt to acknowledge that all we have is now,
right now. So why not make the most of it?

This doesn't mean you have to forget the past, or to learn
from it, nor do you have to avoid plans for the future.
It simply means to value the moment you are in.

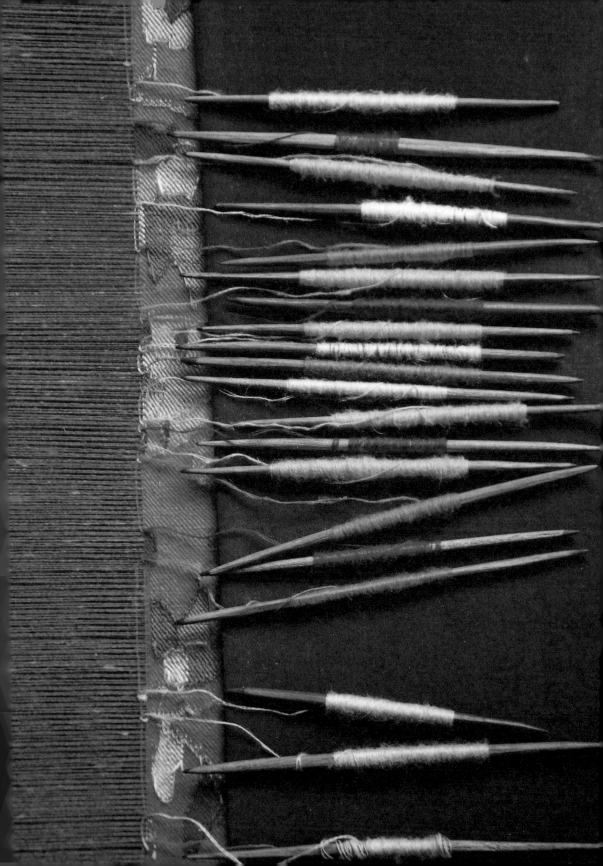

Ignore negativity.

As children we seem to only know *now*. We don't know to plan for the future, are accepting of our past, and most importantly are content in the moment. We don't have to leave this seemingly child-like ability behind.

Think of a time when you responded instantly to a colour or nature's artistry and it made you feel good. You probably forgot all else. There is a sense of freedom that comes with letting go of your personal history.

Perhaps the idea behind this book is best explained by saying I've taken a leaf out of India's colouring book. It seems to me that many who live in India enhance their life with the use of pure, clear and bright colour. Well, so can we.

India is a place that first of all shocks, then surprises and seduces. Colour is everywhere—a stroll down the street can feel like being inside a kaleidoscope. It's a joyful feeling.

Thousands of Indian faces shine with an inner glow above imaginative combinations of clothes belonging to those who don't own much in the way of material possessions. They seem to appreciate the simple things; they have a desire to present themselves in an individual way and understand that how you act towards others is the most important principle.

To me, it can seem as if India has donned the brightest and purest of colours and is walking at the same pace as her sacred cows, contemplating inner peace, and surrendering to the moment while being aware of ancient wisdom. All this Mother India wraps in a vibrant and sensual parcel that creates vivid memories.

The lesson to be learnt from this colourful approach should encourage you to make your own impact with colour.

Colour is part of our interpretation of the world. I love the idea of the exact translation for '*Shlonak?*', 'What's your colour?', an Arab how-are-you greeting used widely in the Gulf countries. Colour is a gauge of our feelings, both individually and culturally, in the way we put it together, and in our reactions to the way others do.

Seek. You just might find what it is you are wanting.

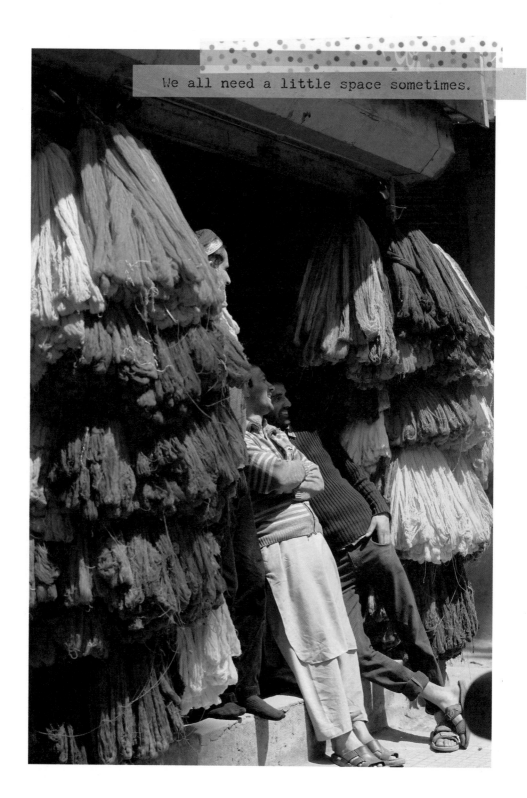

We all need a little space sometimes.

Our eyes are sensitive to the nuances of colour and our emotions to the messages they send. We interpret and distinguish them in our own unique way. Choosing colours that feel right for you gives you a heightened sense of self, and being confident with bright choices gives an impression that you have an appreciation for life.

Everyone can have a colourful life.

Dare to inhabit yours.

Use it to the full. Live a colourful, lived-in life, one that's well worn from use and feeling. Little scratches mend, shines fade, patina builds up and becomes a part of who you are. Some parts of you—a hope, a love, a philosophy—may get lost. They probably weren't a good fit.

Make quick repairs. Or at least try to by being in touch with your soul. Shooting a smile into the air helps mend a hole. A joke can patch a dent or act as a wedge. To forgive is sublime, a miracle.

Show your true colours.

Life's as bright and simple or as dull and difficult as you make it.

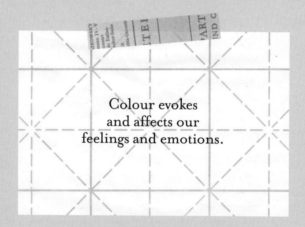

Colour evokes
and affects our
feelings and emotions.

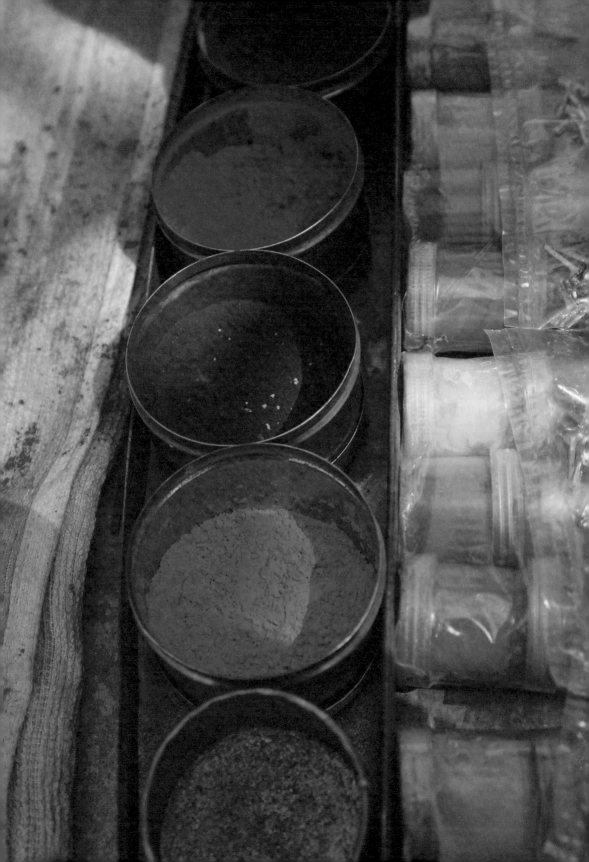

Colour is more than just an expression of personal taste. The way we process colour and how we learn language are connected; colour even affects our perception of the passage of time. Colour is created in our 'grey matter', our brains. It's made from the language we speak, the memories we carry and the moods we feel. It's probably even in our DNA, and is certainly part of the stuff that makes up our right and left brain differences. Colour is naturally linked to our deep emotions and how we make sense of the world—thankfully something we all do differently.

We are born with limited colour vision, develop it over our first three months of life, and can categorise colours before we have the words to describe them.

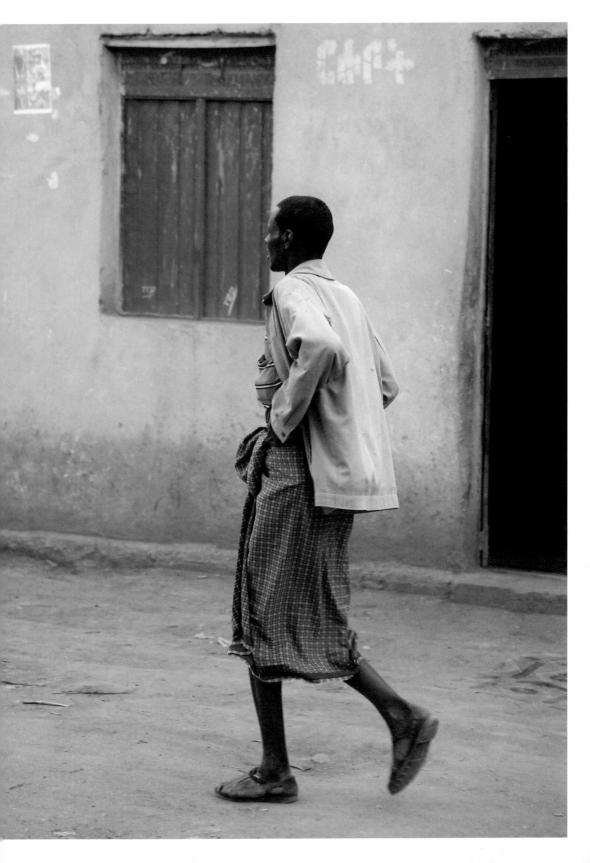

Each person's perception and experience of colour develops due to many influences—language, nationality, political and historical factors, climate, landscape, religion, tradition, gender, age, skin colour, aesthetics, design and contemporary culture. Colour plays a part in the disciplines of science, anthropology, physiology, history and the arts.

Our colour preferences change over time. From the ages of three to six we prefer strong, warm and intense colour to shape. As we get older, our preferences expand to include softer and cooler shades. Adults find subdued colours the most appealing.

The gene that allows us to see colour comes in a high number of variations between the sexes. The main difference between male and female colour perception is psychological rather than physiological. Women are more likely than men to have a favourite colour, one that's soft and muted, while men prefer brights. There's no significant difference between men and women in a preference for light or dark.

Apparently women are more sensitive to colours, and are faster and more precise than men at naming them; they also have a broader colour vocabulary. Did you know that research on primates suggests that women are better able to distinguish between reds because when they were gatherers in prehistoric times they had to distinguish between berries and leaves?

One in twelve males and one in 200 females have some form of colour blindness; 99 per cent of these people are insensitive to the red and green spectrums, with women better able to discriminate in the red—orange spectrum.

Others have colour synaesthesia, sometimes described as a union of the senses. This term is used when letters or numbers are perceived as being inherently coloured.

Black and white do not exist in pure form, except in our imaginations. In order to use colour effectively, it is necessary to recognise that colour continually deceives; it's dependent on its relation to, and interaction with, other colours. The same colour will yield innumerable readings.

To develop an eye for colour simply means to be able to feel colours in relation to each other, to be able to interpret the feeling they evoke, and to see colour in action. It's about observation and articulation. Colour is dependent on form, placement and quantity. It's hard to remember distinct colours, as more often than not our visual memories are weaker than our auditory ones.

Climate affects our colour preferences as much as anything else. Coastal architecture tends to be more vivid than mountainous. Light colours are preferred in warm climates and dark in cold. Where the sun shines a lot, vivid and warm colours are popular, as colour can seem bleached out in strong sunlight, but where the light is less intense or overcast, muted and cooler ones are preferred. As the light in Germany is not very intense, perhaps this explains the lack of brightly coloured German cars on our roads. Pleasingly for those of us with a passion for colour, the popularity of silver cars waned with the beginning of the recession as people, subconsciously or not, learnt an important cheery colour lesson.

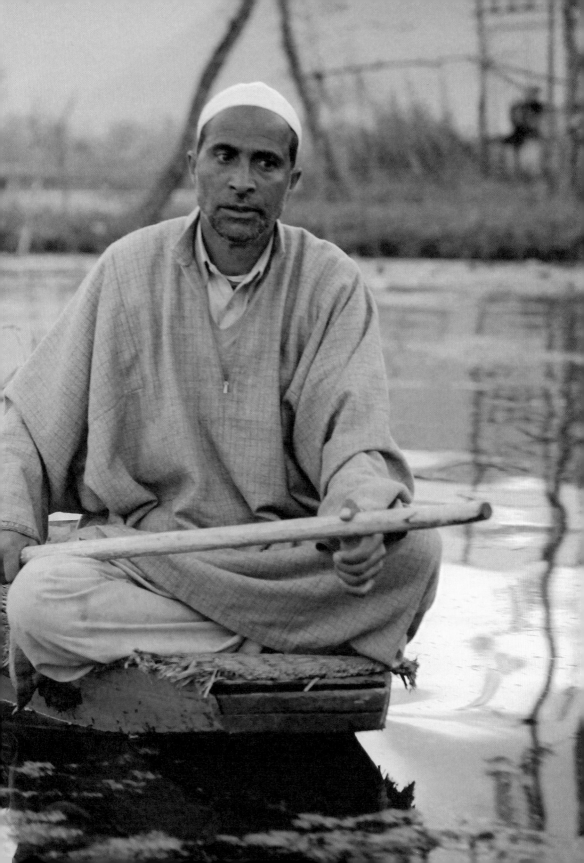

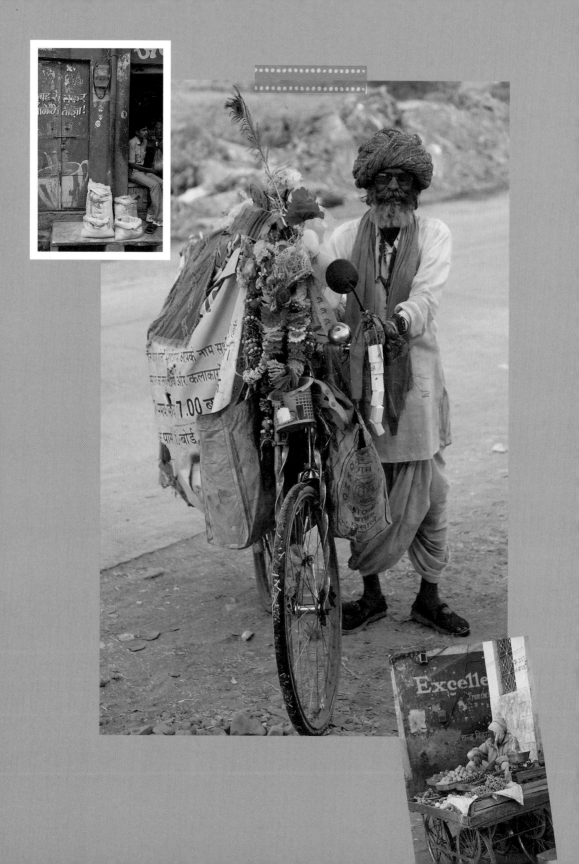

Language has a subtle effect on how we see colour. All languages may have a word for black and white but no colour means the same thing to everyone. Colours are flexible, have nuances and, when clustered together, take on a whole new meaning.

Many languages use the names of colours as a means of expression but often there's no equivalent in another language so the meaning can become lost in translation. 'Feeling blue' has no equivalent in other languages; the German expression *blau sein* (to be blue) means to be drunk; aristocracy is 'blue-blooded' all over Europe, while in Russia 'light blue' means to be homosexual.

An eye that is black in Britain, Italy and Australia is blue in Germany, purple in Spain and *oeil au beurre noir* (black butter) in France. You may have seen someone beaten black and blue but if you're German you'd say green and blue, or if you're Italian, just plain black. Blue jokes turn green in Spain, yellow in Hong Kong and pink in Japan. The French are green with fear, the Italians blue or white. Goldfish are red fish in Italy and France; a sleepless night is a white night in France, Italy and Spain; and in China adult movies are yellow, not blue.

Your language structures the way you see the world, especially when comparing colours. You could even say it colours everything. The way we process colour and how we learn language are connected—each of us has two hemispheres in our brain, but mostly only one is used for language while colour crosses over both hemispheres.

In many of the world's major languages, there are eleven colour categories (red, green, blue, yellow, black, white, grey, pink, orange, purple and brown) to describe colour. All languages contain a word for black and white. If a language has a third colour, it is always red; a fourth is always green or yellow. When there are five, it is both green and yellow, the sixth is blue, the seventh brown, and if there are eight, either purple, pink, orange or grey. Colour vocabularies of other cultures tell us about different ways of thinking. The Himba tribe in northern Namibia have five (*zoozu*, *vapa*, *borou*, *dumbu* and *serandu*), all of which cover a broader scope of colour: *serandu* would be red, orange and pink in English, while *zoozu* covers a variety of dark colours that we would call dark blue, dark green, dark brown, dark purple, dark red or black.

Once the Welsh also had only five categories for colours, as they had no need for more. They use words such as *gwyrdd* for green, yet the English 'grass' literally translates to 'blue straw' because the Welsh word for blue, *glas*, can accommodate all shades of green.

Japan has two colour traditions. Shibui is an aesthetic based on the colours and combinations of nature, while the Kabuki tradition features bright splashes of colour and graphic imagery. Japanese adjectives define a colour in terms of the meanings or feelings associated with it. *Iki* means sophisticated or chic, *shibui* subdued or restrained, and *hannari* mirthful or gay. *Ao*, the Japanese term for blue, can be confusing as they also call green traffic lights *ao*. *Ao* does not correspond to the English word green, nor does it mean blue. The Himba tribe also do not differentiate between blue and green.

Don't waste a single moment.

East Asia tends to make the greatest distinctions between colour and its meanings. In India, Holi, also known as the Festival of Colours, is celebrated at the end of winter and at the rebirth of spring. It's a kind of thanksgiving festival where *hola* or prayer is offered to the Almighty for a good harvest and a bountiful season. The essence of Holi is to worship with joy, and that involves colour. It is said that Lord Krishna celebrated Holi with bright orange tesu flowers. The goal is to dissolve the differences between individuals and to reach the Divine. Dressed in white, people throw coloured powder or water at each other to celebrate the triumph of good over evil. Colour works its magic by making Hindus, and some Buddhists and Sikhs, merge into one big fraternity, without any distinction of caste, creed, colour or sex. On the last day they revert to wearing white again and embrace each other, sharing peace and serenity.

The Indian word for caste, *varna*, also means colour. Brahmans, the sacred caste who taught and studied, wore white, also associated with spirituality. The militant caste, the Kshatriyas, wore red, a colour of passion; the Vaisyas, the mercantile caste, wore yellow; and the Sudras, the servile caste, wore black.

In traditional Chinese clothing, darker colours were favoured over light while the popularity of subdued tones in China stems from the Sung, Ming and Ching Dynasties (from 960 to 1911 CE) when the officials in the emperors' ranks wore them. The Chinese associate colours with seasons—green for spring, red for summer, white for autumn and black for winter.

Blue, green and white are well liked across most countries and tend to share similar meanings, while black has a considerable range of different meanings and acceptance. Brides in the West wear white, while Indian brides wear red; both colours symbolise purity in their respective countries.

Black was worn by the wealthy and the nobility in all parts of Europe during the Renaissance, while the Protestant Reformation saw people dressed according to both rank and sex. Puritans wore sombre dress, and fines were imposed on people who wore bright clothes. Radical Protestants saw black as the most virtuous and dignified colour to wear.

The names of colours often reveal their origins. Indigo is from India; gamboge, a mustardy yellow, from Cambodia. Most ancient pigments have had many names that reflect the cultural traditions of a period or their geographical area, while some simply come from errors made by the compilers.

Some colours manage to be cross-cultural, such as red's association with danger and things that make your heart beat faster; white's with peace; and green, the most frequent colour in the natural universe, with the environment.

Colours can seem more at home in what feels like their own natural environment. A bright red salsa feels perfect in Mexico and the browns of chocolate feel natural in Switzerland, while the green of the Catholic Nationalists in the south of Ireland feels appropriate, as does the yellow of cheese in France.

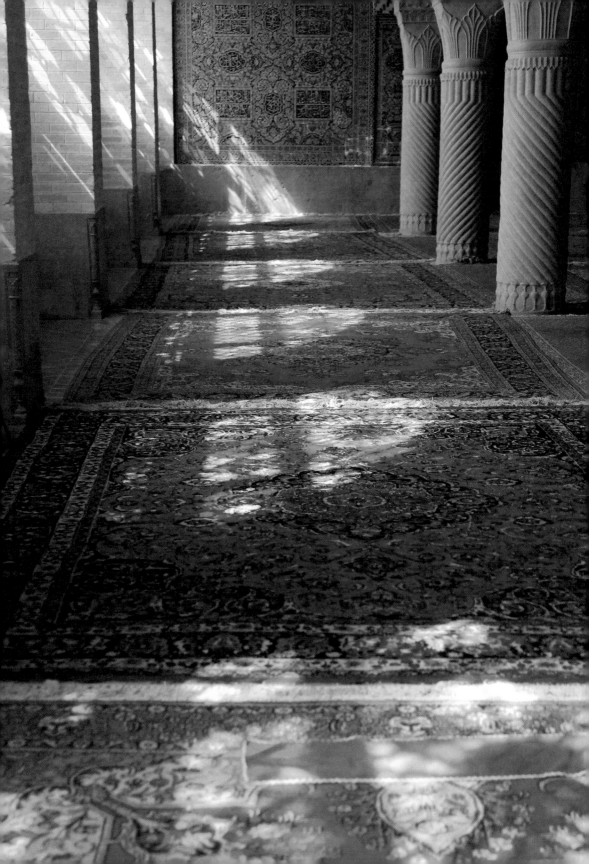

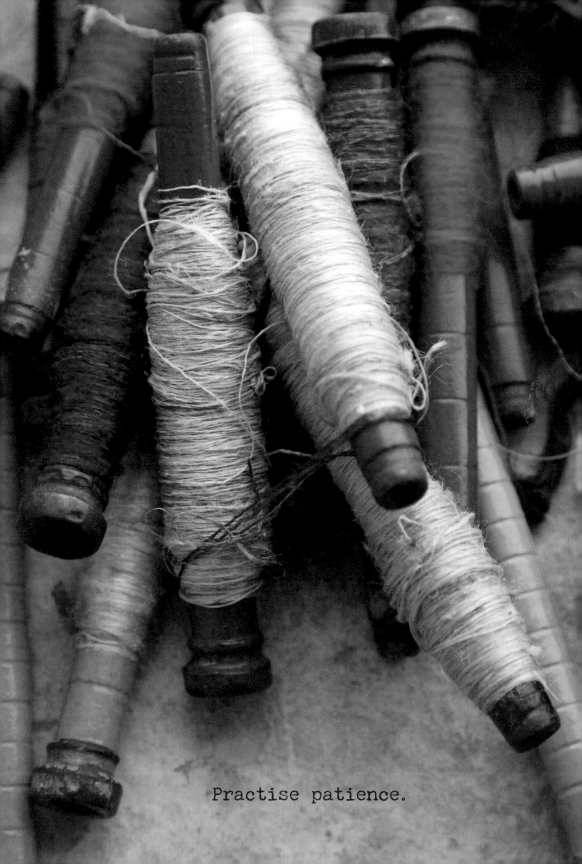

Practise patience.

The clan tartans in Scotland embody nostalgic and symbolic values that evoke emotional responses and loyalty. In Africa colours that look great together because they clash could be seen as representative of the divide between developing and developed countries; a Zulu woman can tell a story by using different-coloured beads and combinations, as each colour embodies a wealth of symbolism.

Finnish colour aesthetics are among the most highly developed, with the nuances of shades, not just a general name, being very important. In South America, despite the prevalence of Catholicism, colour and design from the Incan, Mayan and Aztec cultures have had a powerful influence.

Cultural and symbolic messages designated by colours are particularly apparent when linked to weddings and mourning; religious and spiritual traditions also have a strong influence. In Tunisia—just one of many countries with two religious traditions—green, white and red are significant to Muslims while blue and white are important to Jews.

Black, associated with Good Friday, is the colour of mourning in Western and Christian cultures, where death is seen as the end of life, the absence of light and a time of darkness. In Asian cultures where death means a new beginning, one of purity and light, white is appropriated as the colour of mourning. But there are always exceptions, so should you be Korean you may don dark blue as your colour of mourning; in ancient Egypt it would have been yellow.

Colour preference is cultural as well as personal. If you're Greek, blue is capable of warding off evil spirits. Historically, in Muslim countries green, the colour of paradise, is preferred over all other colours; gold and yellow were seen as negative in Iran, disapproved of in Latin America but as positive in the Buddhist and Hindu countries of India, Ceylon, Burma, Cambodia and Laos. Red has been linked to prostitution since the mid-nineteenth century, hence 'red light districts'.

The world is a place where on one hand we have the melding of diverse cultures, and on the other people embracing their cultural heritage, intent on preserving it. Colour provides a means of doing both. Each national flag distils a nation's essence—its values, beliefs, traditions—into just a few shapes and colours. Flag designs have evolved over millennia and there is much to be learnt from vexillographers who apply these hallowed principles when designing a flag—simplicity, distinctiveness, two or three colours, only meaningful symbols that reflect culture or history, geography or religion. Apply the same principles and watch yourself fly.

A real living space, a home sweet home, is made from living, not decorating, by participating in the personal, in what comes naturally, and the fun of everyday life. Your home is an expression of you. What better way to express yourself than to lose yourself in a love affair with colour?

Glorious colour surrounds you wherever you are. Let it wash over you and win you over, excite all your senses, not just your sight. Colour is a shortcut to the senses and emotions and, like musical appreciation, can be learnt. Be a professor of unexpected combinations.

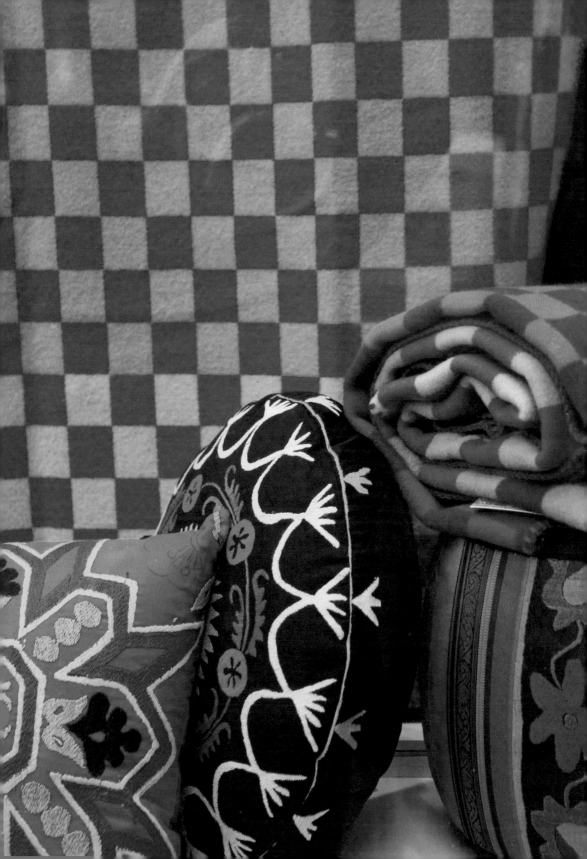

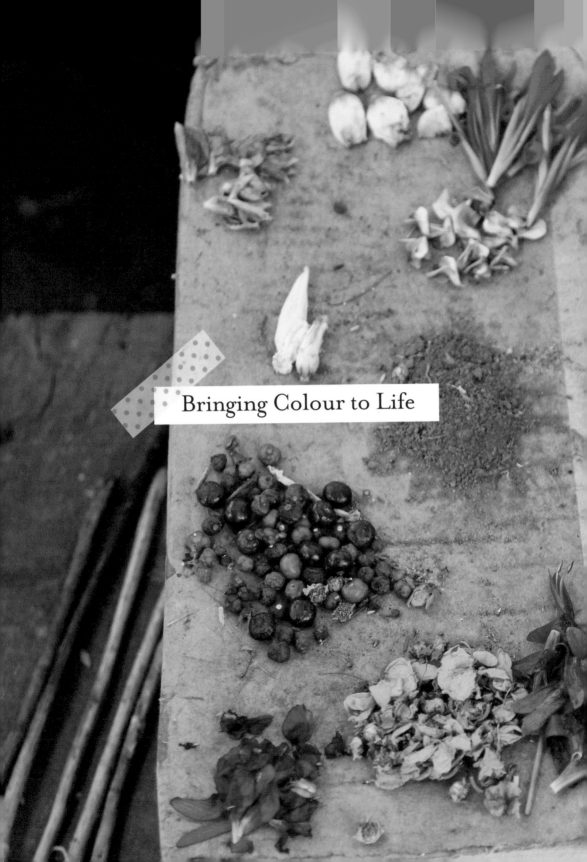

Bringing Colour to Life

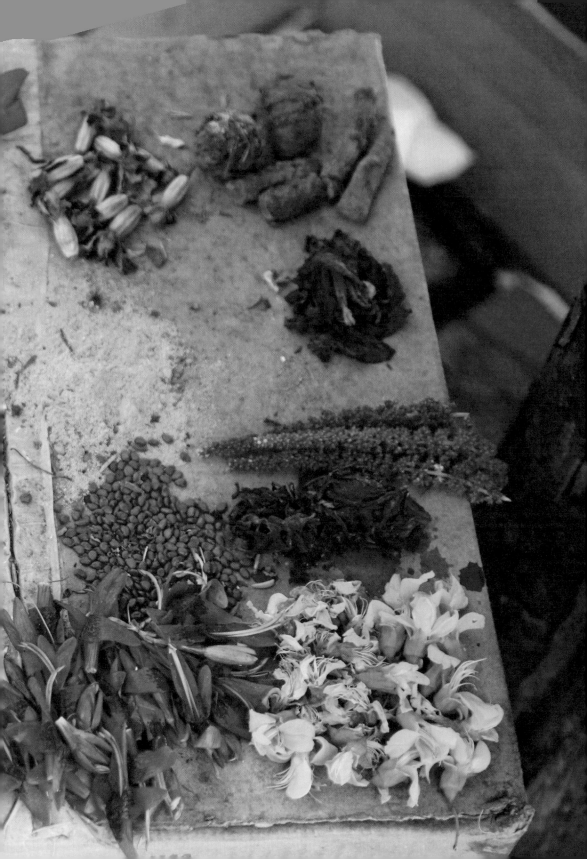

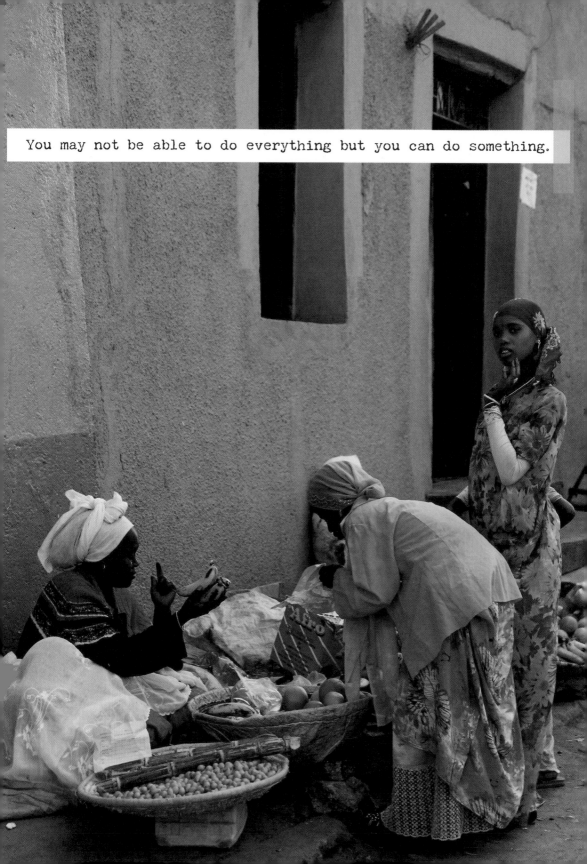

You may not be able to do everything but you can do something.

I don't think there is such a thing as
a bad colour. Only bad use of colour.
Colour is a language in its own right, one
that words struggle to convey. Colours bear
history in their names and their molecules;
they are the heirs of art, craft and popular
tradition. The tools of reinvention.

The role of colour has seen significant
changes in cultural expression and social
communication. In mediaeval times
it signified key identities, values and
ideas and was valued for its intrinsic
material qualities, brilliance and lustre.
A monochrome age followed with Puritan
neutrality and black, and artists used colour
naturalistically rather than symbolically.
During the twentieth and twenty-first
century it has been studied scientifically,
with its material qualities seemingly
becoming appreciated again.

Fashion is a major contributor to break-throughs, offering moments for certain colours to shine, but colour also has a useful purpose when used for system building. Colour schemes are becoming as important as individual colours, as they take their meanings from the relationships between each other.

All colours can be perceived according to their nature, and assessed according to degrees of hue, brightness and saturation. They are warm or cool, wet or dry, silky or rough, and aggressive or soothing.

There are a number of systems for measuring and classifying colour. These rely on three parameters—length of the dominant wavelength (determining hue), level of saturation (strength of the hue's intensity) and brightness (a scale of tonality). In this context hue means a pure colour, without a tint or shade added to it.

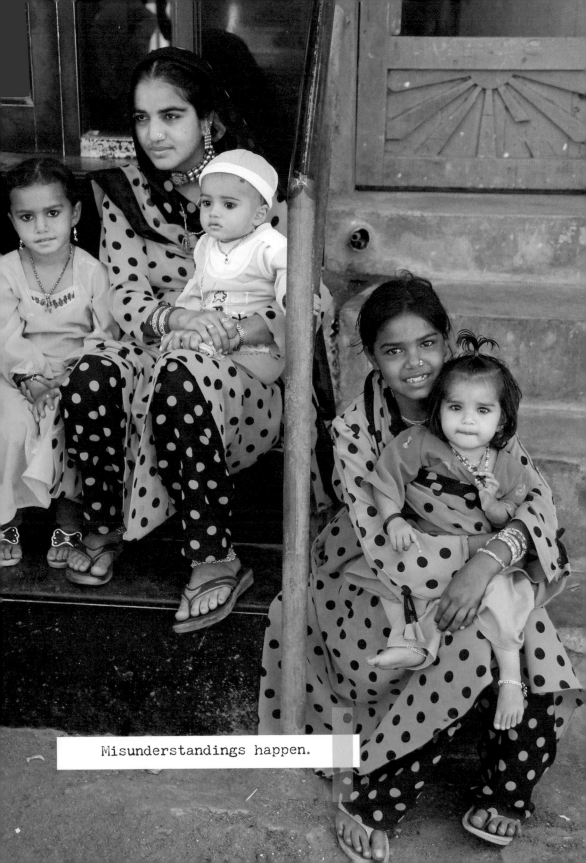

Misunderstandings happen.

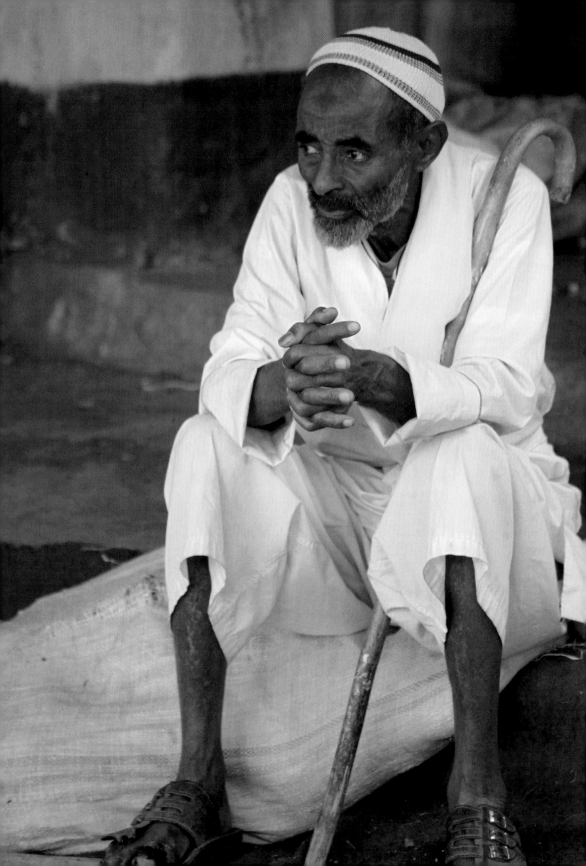

The list of colourants manufactured industrially today fills 9000 pages in nine volumes of the *Colour Index International*, the colourists' and dyers' bible. They haven't all been given names but are catalogued uncompromisingly by hue, use and a number that denotes their chemical composition. About 600 are pigments, and more than 900 are dyes.

Dyes can be absorbed while pigment sits on the surface. The pigment produced in the greatest quantity is white, a non-colour, yet this kind of white did not exist before the twentieth century. Another more commonly used classification for colour matching is Pantone.

The use of pigments and dyes is so universal we barely notice it, yet colours were once among the most precious and expensive of substances. One of the richest sources of colour is the colouring of yarn or cloth. An everyday process most of us take for granted. This requires dyes, while the painting of a surface uses pigments or lakes.

Dyes are soluble coloured compounds suspended in a medium, while pigments are pure colours in powdered form suspended in an insoluble medium, such as oil to make paint. The use of dyes is probably as old as that of mineral pigments themselves. They've been made from plant, lichen or animal extracts since Neolithic times. When they're organic they show the hand of the dyer. Japan has specialised in producing new natural colourants that are dramatically less toxic and environmentally damaging than synthetics. Curiously, almost any shade of colour can be made using either cultivated or wild plants, except green.

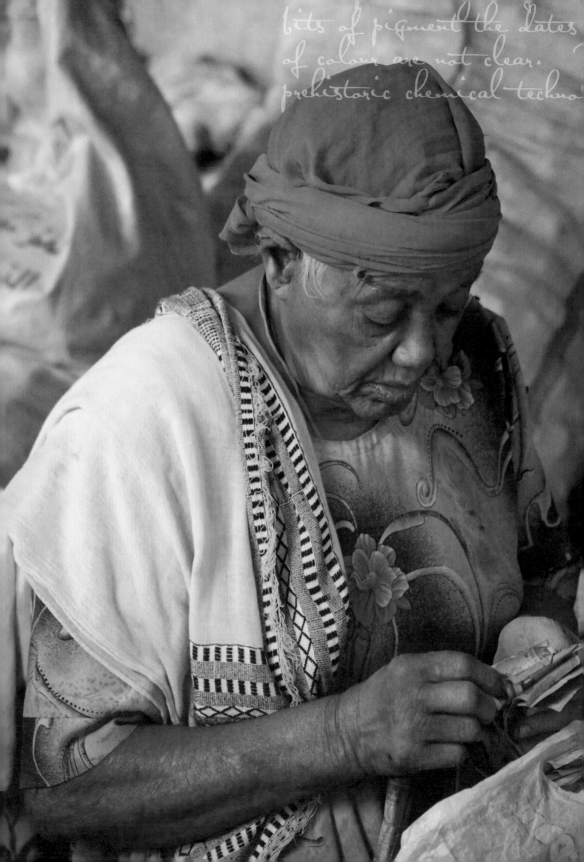

bits of pigment the dates
of colour are not clear.
prehistoric chemical techno

Some traditions are becoming lost in our quest for new technology, but colour and technology remain closely linked.

Today, aside from ochres, which are mined, pigments, lakes and dyes are made using specialised chemicals. Dyes react in very small quantities and the degree of absorption varies between animal products, with a protein base such as wool, silk, leather or parchment not taking dye in the same way as cellulose-based vegetable fibres, such as linen, hemp, cotton and paper.

Despite analyses of traces of colour and bits of pigment, the timing of the evolution of colour is not clear. Erich Pietsch's book on prehistoric chemical technology theorises that Ice Age man was looking for colours in ochre quarries. The oldest known dyed fabrics are from about 6000 BCE, but as textile fibres are fragile, few pieces exist to provide concrete proof of when the colour-dying processes actually developed. Ancient textiles have survived best in the dry climate of the Mediterranean, especially Egypt.

The use of coloured earths dates all the way back to the Palaeolithic period (350,000 BCE) when red earths were used to tattoo the flesh of the living and ochres to redden the bones of the dead. Browns and whites came into play during the Upper Palaeolithic period.

There's an absence of blues and greens in ancient paintings, with the exception of those clever ancient Egyptians. Egypt's 3000-year-old wealth of decorated walls and objects are in two colour groupings—one for naturalistic purposes, landscapes and scenes from everyday life, and the other for religious purposes, funerals or medical artworks where the pallete was restricted to six colours, each charged with symbolism and associated with a precious stone or metal, which were used in juxtaposition to each other. As with all symbolic colours, to mix or blend them renders them meaningless.

Roman murals can be found all over Europe; many are frescos, where the paint was embedded in wet plaster. But few ancient Greek coloured wall paintings and sculptures have survived.

The Greeks, the first rationalists, made a distinction between colours of thought—black and white—and colours of substance—red and yellow.

It's not what you look at but
how you choose to see it.

Madder plant was used to dye the red linens in the Old Kingdom tombs of the Nile valley. Safflower, a source of both red and yellow, was found among the seeds in Tutankhamun's tomb, while ancient texts report Egyptian dyers used indigo; kermes, made from parts of the cochineal insect as a source for red and purple; archil, a red-producing lichen; alkanet, a herb whose root produces red; buckthorn berries and saffron to make yellow; mulberry juice for red and purple; and tannins as acidic fixatives. They are also said to have invented mordanting, the technique for setting dyes, making them colourfast. The Romans used madder for reds, weld for yellows, and indigo for blues.

A vogue for coloured fabrics came about during the twelfth century. If you'd lived during the Middle Ages you'd have witnessed the international textile industry's quest for more colours. The palette broadened and many new pigments and dyes were created. These were traded along the same commercial routes as spices, and were sought after as much for their medicinal properties as their creative value. They were commodities, as valuable as spices or silk, and fortunes were made and lost in the textile industry and also the international shipping that supported it. Many communities that began by importing them moved on to develop a local production of their own.

During this period bright fabrics were a luxury, as quality dyes and mordants were expensive. Textiles became the backbone of the European economy, and animal, vegetable and mineral products meant a new palette in paintings.

By the sixteenth century there was stimulated demand for colouring agents and, in turn, increased trade. Pigments sold as pastes, nuggets or dried, binders and mediums were usually bought from spice sellers, called druggists, then ground and mixed.

During the Elizabethan period, the colours and materials used for clothing were dictated by the Sumptuary Laws. The colours, including yellow, provided information about the status of the man or woman wearing them. Colour was not only dictated by the wealth of the person but also reflected their social standing, representing many aspects of life—social and religious, including biblical and Christian symbolism. The symbolic meanings attached to yellow were renewal and hope.

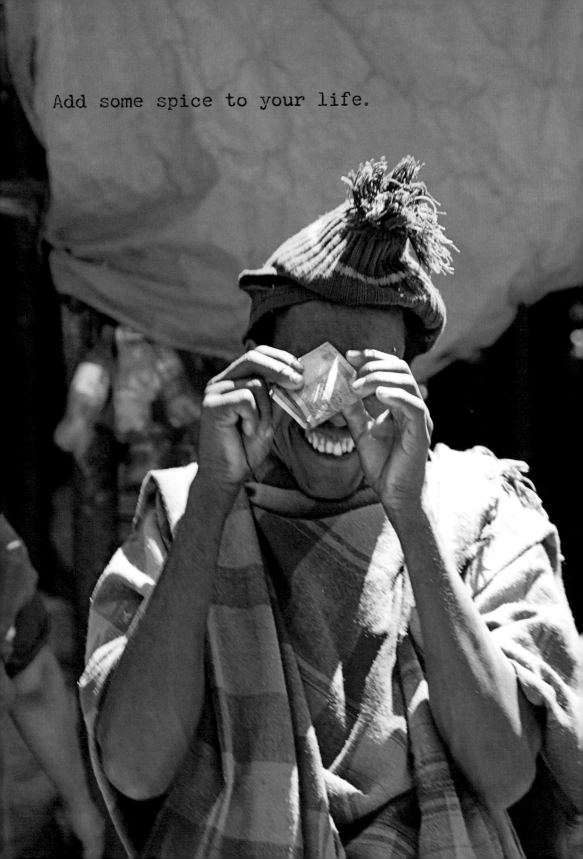

Add some spice to your life.

Until the eighteenth century, ready-to-use dyes and paints were rare, but as a result of the work of those secretive, mystical alchemists of the seventeenth century and the scientific revolution of the eighteenth century, synthetic pigments and dyes were developed, and with these came a greater range of colours.

In 1841 an American painter, J. Goffe Rand, patented a tube made from sheet tin. A year later the English firm Winsor and Newton changed the patent by improving the cap and began marketing tube colours. Artists have been grateful ever since.

The choice of colours also improved when printed wallpaper made its first appearance during the seventeenth century. Wallpaper designs imitated fabrics imported from India, China and the Arab countries, but life really changed when Christophe-Philippe Oberkampf, the son of a Bavarian dyer and the first to devise block and roller printing for calicos and chintzes, founded a workshop in the town of Jouy in northern France in 1759. His success was so phenomenal that he went on to patent copper roller printing, later perfected by the English in Manchester.

Michel-Eugene Chevreul, who studied the psychology and perception of colours and created the first chromatic colour wheels, established the law of contrasting and complementary colours in the nineteenth century. As the director of a dye works, he also established a colour classification system, using the categories of tint, hue and saturation, with colour value determined by the degree of intensity, purity and greyness. He defined colour intervals and expressed them in chromatic circles, a forerunner to the colour wheel, and other scales.

The word 'pastel' comes from the Latin *pastilles*, meaning small loaf or block, and indicates soft, pale colour as well as the sticks used for drawings. The luminosity of pastels led colour specialists to use them for their charts and the first colour wheels.

Broaden your horizons.

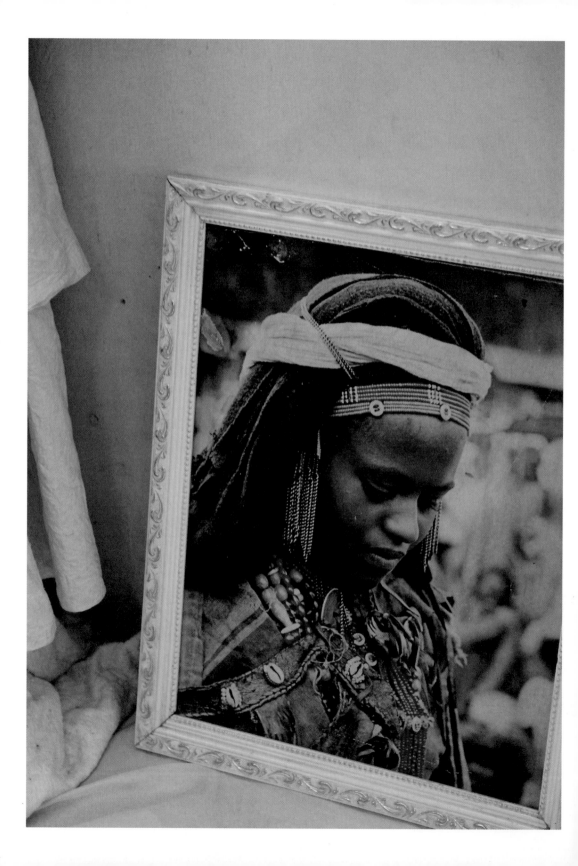

Although experimental forms of colour photography have existed since the 1870s, it wasn't until 1904 that Louis and Auguste Lumière invented the Autochrome, the first true photographic colour process. It used a dyeing process that coated the image with juxtaposed granules of potato starch dyed in three primary colours.

Colour photography today involves light-sensitive chemicals or electronic sensors that record colour information at the time of exposure. This is done by analysing the spectrum of colours into three channels of information—red, green and blue. It's an imitation of the way the human eye senses colour.

It's hard to imagine how the French artist Jean Dubuffet believed there is no such thing as colour, only coloured materials. Philip Guston, the American painter, may have thought of paint as 'only coloured dirt' but I love how Matisse, the French master, felt about it: 'I do not literally paint that table, but the emotion it produces upon me.' His paintings have stood the test of time, in part because of his use of colour.

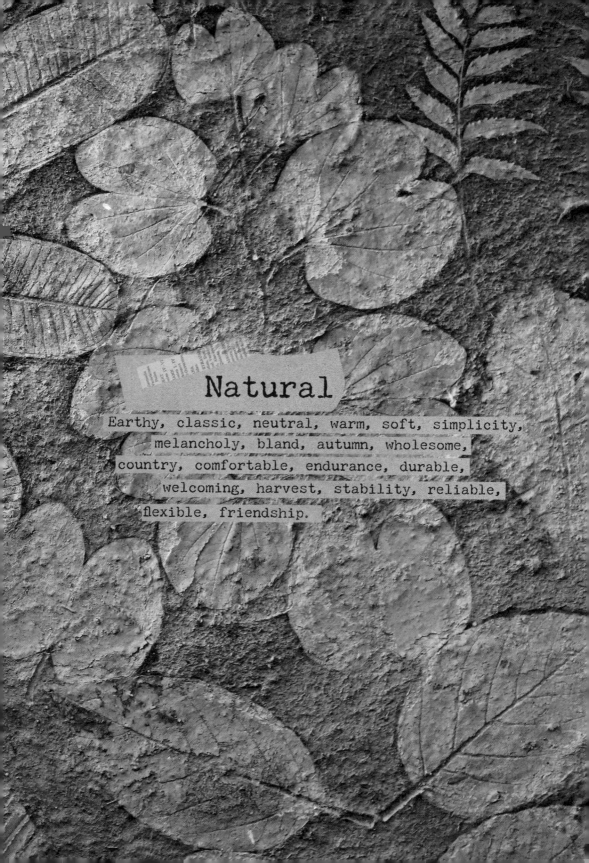

Natural

Earthy, classic, neutral, warm, soft, simplicity,
melancholy, bland, autumn, wholesome,
country, comfortable, endurance, durable,
welcoming, harvest, stability, reliable,
flexible, friendship.

You are free to be you.

Above all else, act naturally. Created by nature, made with ochres, mud and earth, vegetables and nuts, natural colours say much without ever shouting. Think of the beautiful simplicity of brown paper tied with string.

Nothing makes a statement about honesty quite like nature's own colours. When left in their natural state, fibres such as linen, cotton, wool, silk, hemp and jute have their own texture, integrity and story to tell. One born of nature.

Nature's neutral naturals, the very best foil for all other colours, are sympathetic mixers and make a quiet background.

The natural choice of St Francis of Assisi, earthy colours suggest simplicity, discretion, pragmatism, humility and, in the past, poverty.

There was once a marked difference between the vivid colours of the court and those in the street. Brown, at one time the colour of the poor, is now the colour of calm, good sense and adaptability. Many a sensible choice is followed by '... it will go with everything'.

Chocolate and coffee are two delicious ways to appreciate seeds in natural tones, especially when coloured by milk. Other foods too—walnuts, chestnuts, almonds and mushrooms—have lent their names to tones.

Linen, made from the flax plant (*Linum usitatissimum*), is among the oldest of all textiles. Dating back many thousands of years, it typifies the natural story. With its hand-woven texture, linen is labour-intensive to manufacture and valued for its ability to breathe, making it cool to wear during hot weather.

Be your own judge.

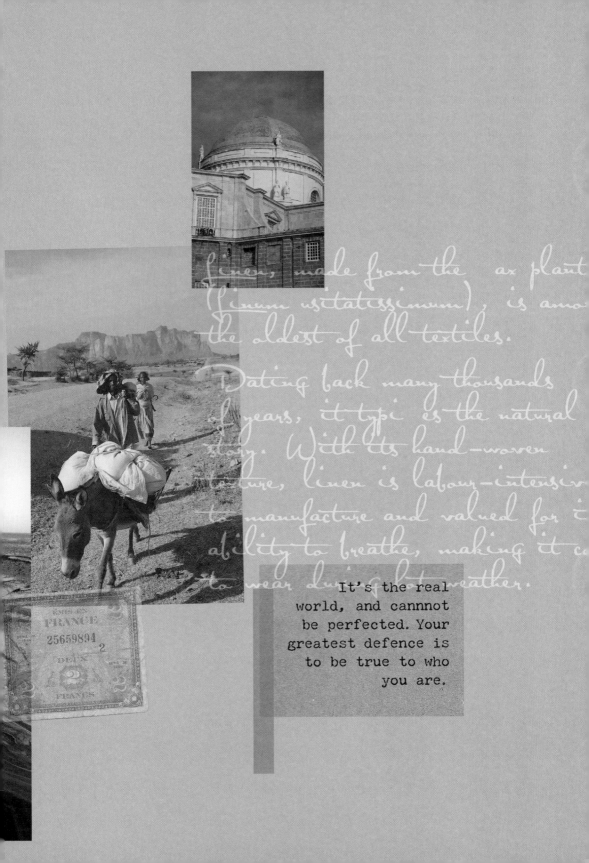

Linen, made from the flax plant (_linum usitatissimum_), is among the oldest of all textiles. Dating back many thousands of years, it typifies the natural story. With its hand-woven texture, linen is labour-intensive to manufacture and valued for its ability to breathe, making it cool to wear during hot weather.

It's the real world, and cannnot be perfected. Your greatest defence is to be true to who you are.

The earliest records of a linen industry are 4000 years old, from Egypt. Sometimes used as currency in ancient Egypt, linen was seen as a symbol of light and purity. The Egyptians also wrapped mummies in it as a display of wealth.

When the tomb of Pharaoh Rameses II, who died in 1213 BCE, was discovered in 1881, more than 3000 years later, the linen wrappings were perfectly preserved. Similarly, when Tutankhamun's tomb was opened, the linen curtains were found intact. Ireland too has a long history of producing fine linen.

Think camel, beige, sand, Africa, safari clothes and natural-tinted animals and you begin to get an overview of how many earthy tones and variations there are, including those designed to fit in with their environment or camouflage.

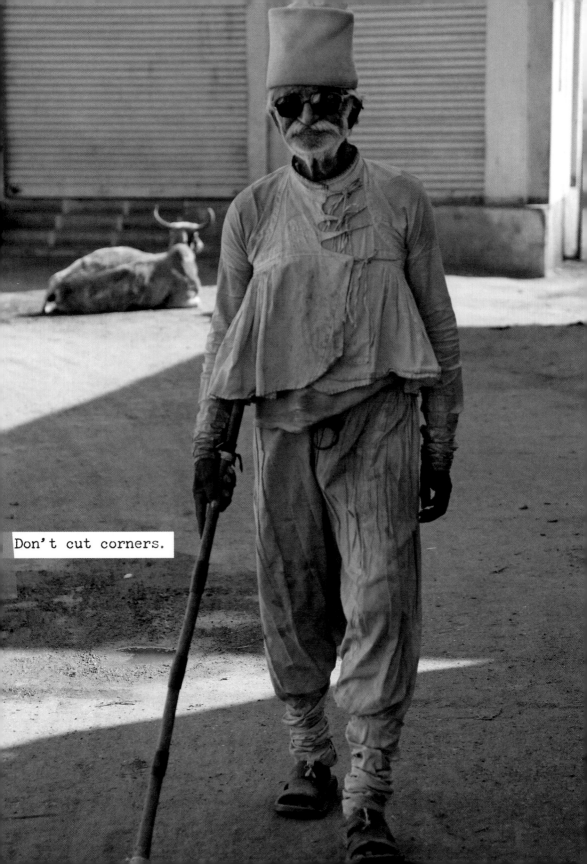

Don't cut corners.

Think outside the square.

Let go. Let it be.

Ochre, a natural earth pigment found all over the world, was one of the first materials to be used by human beings to make drawings and paintings. Pieces of haematite, a compact form of iron oxide, worn down as though they had been used as crayons, have been found at 300,000-year-old sites in the Palaeolithic caves of France and Czechoslovakia.

The oldest record of ochre-mining activity is at the Lion Cave, a 43,000-year-old ochre mine in Swaziland. Mentioned in the Book of Genesis, ochre was a popular colouring that was used to beautify architecture in France during the French Empire. Ancient Egyptians also used it for the same purpose.

Aboriginal Australians have always used ochre for ceremonial body painting, traditional rituals, art and the message diagrams associated with their nomadic lifestyle.

Some of the earliest Aboriginal art collected by Europeans was made using ochre on eucalyptus bark or other timbers. The artists of the Kimberley region of Western Australia have continued with this tradition by using natural ochres and earth pigments. These works have a close affinity to the land and their country.

The collection and preparation of the raw ochre is incredibly time-consuming, and the blending of a myriad of colours requires knowledge and dedication. Some ochre is heated up, with the depth of colour depending on the temperature achieved. Once ground, the ochre is mixed with a binder. Before commercial binders were available, natural binders such as garliwun (tree resin), bush honey, egg yolks and kangaroo blood were used.

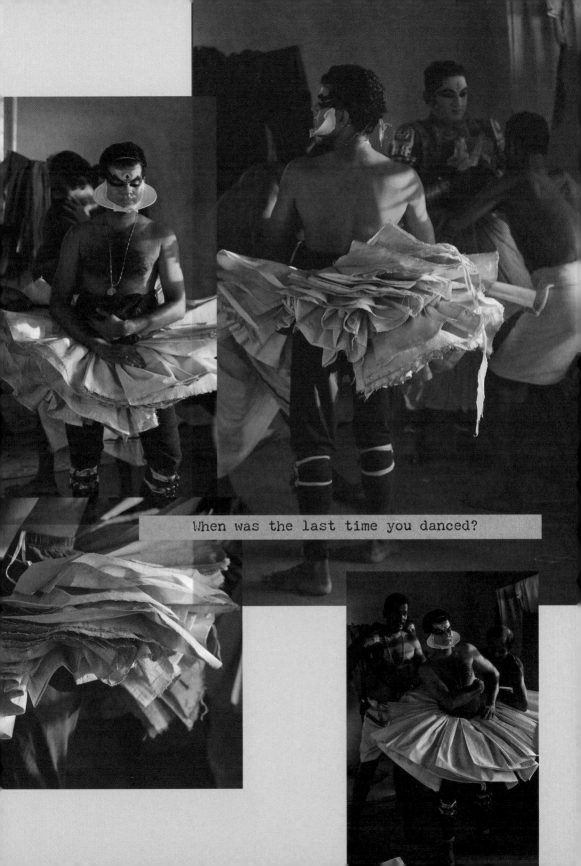

When was the last time you danced?

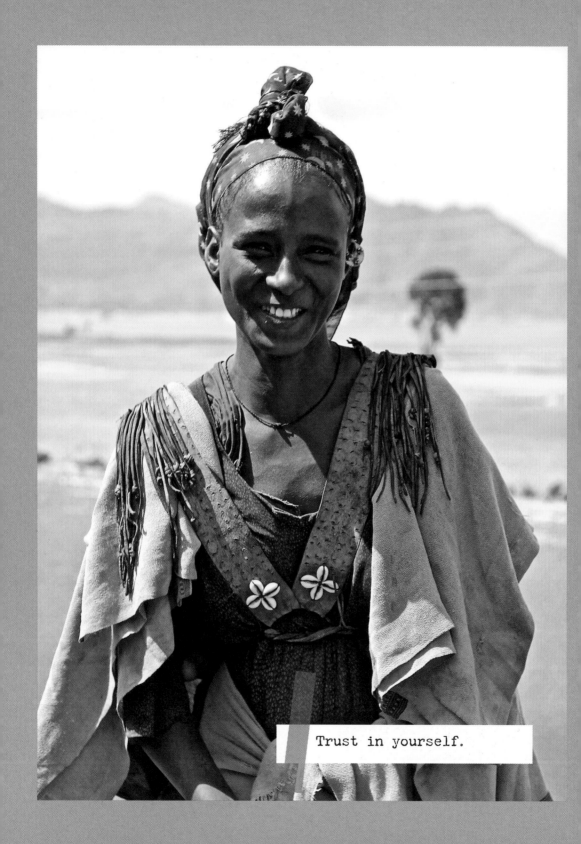

Trust in yourself.

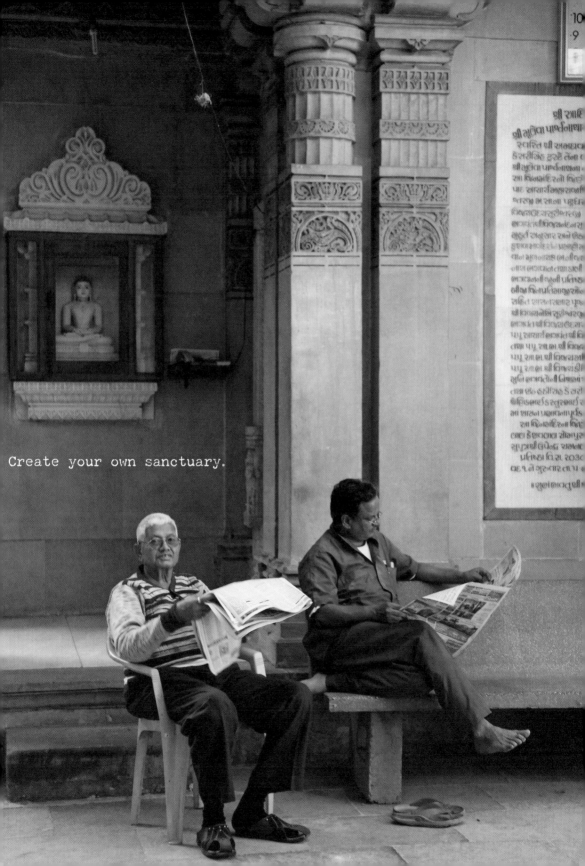

Create your own sanctuary.

Happiness sneaks in unexpectedly if you let it.

Live by your own code.

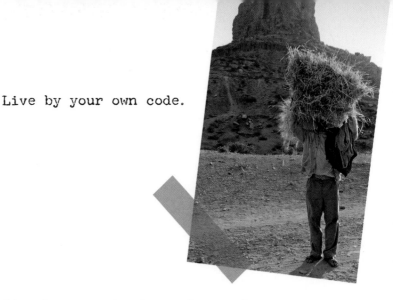

The thickness of the ochre varies with each artist. Some prefer
it thick and showing the grain, while others use finely powdered
ochre to achieve a translucent effect. The original ochre masters
would prepare the canvas with ochre, leave it to dry, then rub it
back with a flat stone to achieve minimal ochre imaging. Ochre,
being a natural pigment, is not affected by direct light, and is
extremely durable in all temperatures and climates.

Nature and the seasons are an amazing inspiration—fields
of wheat, bare branches, the earth. There is a subdued but
inspiring palette of colours, muted neutrals, to be found in
the natural world. All are a wonderful foil for other colours,
brights and pale alike.

I love the innate imperfection of natural materials. And of
course they have a texture that is often an essential ingredient,
adding warmth, depth, interest and richness to a room. Think
stone, the patina of unpainted waxed wood that's been marked
by the passage of time, worn linen bleached by age and washing,
rusting metal, almost fraying soft raw silk and cosy woollen
blankets. A hand-knitted cashmere rug. All treasures that speak
for themselves, of the homemaker's heart, of a home that's
comfortable and filled with living.

Act Naturally X Choose those things that have been made by hand. Appreciate the hand of the maker. X Marvel at nature's natural selection. X Naturally, you prefer organic. X Keep it simple and keep it real. X Wear only natural fabrics. X Conjure up thoughts of a perfect life. Go after it. X Offer help with natural disasters. X Keep company only with people who have integrity. X Learn from another's experience. X Telling the truth should come naturally. X Admire nature's way.

X Find *Help!* and bob around to Ringo Starr singing 'Act Naturally'. X Shop directly from the grower. Make him smile. X Carry a straw basket. Enjoy its leather handles aging gracefully. X Read from the pages of a book, not a screen. X Nurture your wooden furniture. Think of the tree that grew for you. X Wax lyrical about the environment. X Come from the heart. X Get to the heart of the matter. X Appreciate natural justice.

X Act on your instincts. X Do what comes
naturally. X Try natural therapies. X Stay
neutral when those around you are arguing.
X Dust with a feather duster. X Study
Rembrandt's works in detail. X Make friends
with Vermeer. X Be reverent towards the
Renaissance. X Wonder at the supernatural. X
Smile. X Hug a tree. Or two. X Make things
that last. X Listen to the soundtrack from
Out of Africa. Visualise the colours in
the movie. X Hoot at an owl. X Watch a
wombat waddle. X Eat oats. They're good for
your heart. X Avoid white sheets of paper.
Use recycled brown paper instead. X Value
experience. Listen to the wisdom of years,
knowing nature has played a part in history.
X Sow some seeds, practice patience, then
watch them sprout. X Rub your hand over a
river stone, feel nature's seamlessness. X
There's a surety in roots. X Trees reach
but never hold.

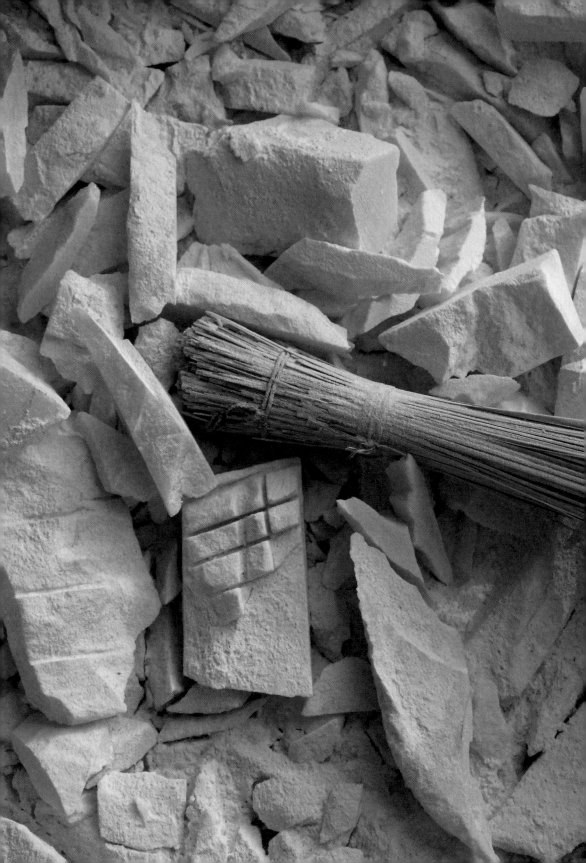

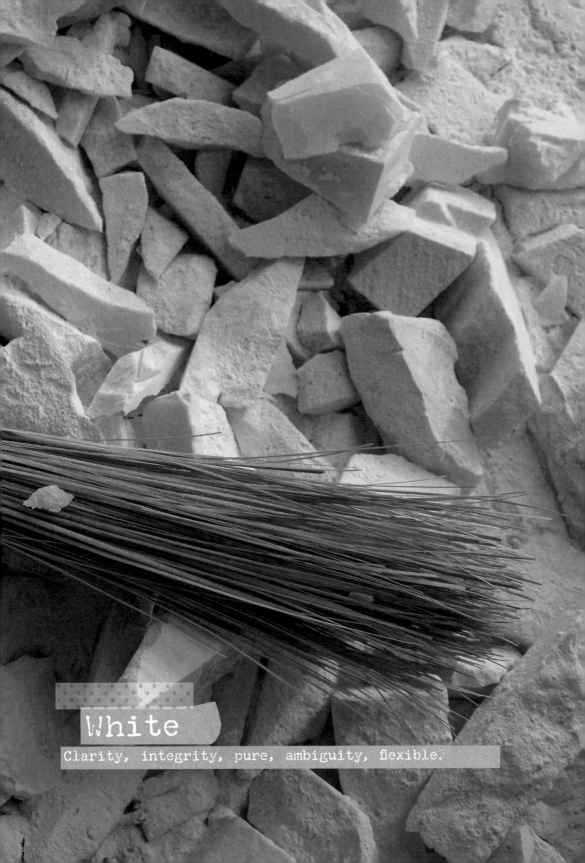

White

Clarity, integrity, pure, ambiguity, flexible.

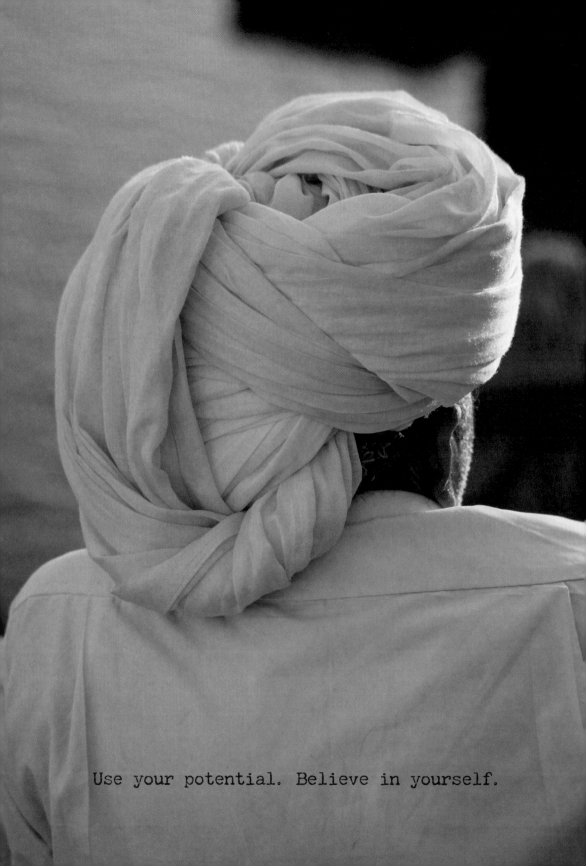

Use your potential. Believe in yourself.

White repels all light and is the absence of colour, and although it's often thought of as a non-colour, it is far from it. If you spin a colour wheel fast enough, all the colours blend to create white. White is the sum of all colours.

Being neither a secondary nor primary colour, white is a good place to start. It is the colour of the dove of peace and many a christening or wedding gown; it so often represents purity that it's easy to forget that in the East, in China and Japan, it stands for death and sickness. In India widows wear white and disconnect themselves from the pleasures and luxuries of an active and normal life, but Gandhi gave it a whole new meaning when he embraced natural white Khãdi cloth and salt to make his point.

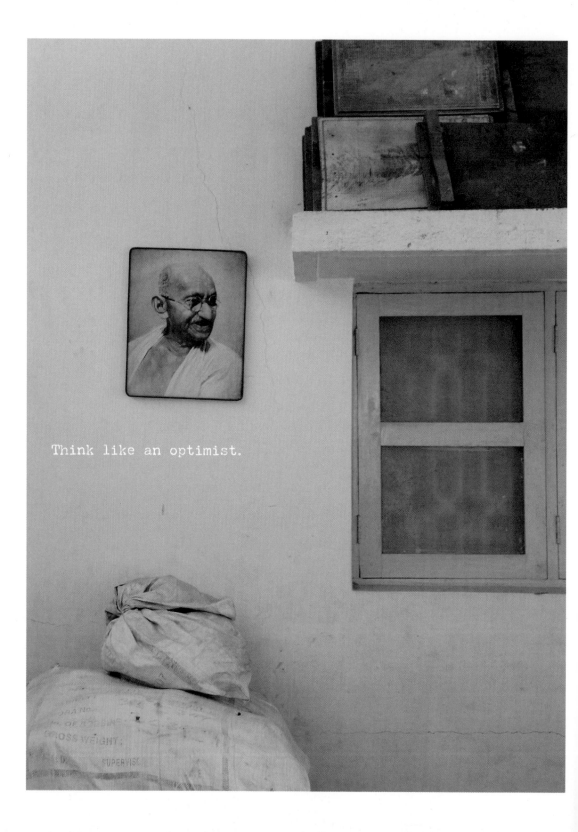

Think like an optimist.

Focus on what it is
you want. Forget what
you don't.

In Ethiopia, Netelas—white scarves and shawls with endless
borders—are worn to unify and equalise. Isn't that a lovely
thought? For a scarf fetish person like me, it feels like heaven
to be surrounded by Orthodox Ethiopian Christians who have
respectfully covered themselves with white during an open-
air church service. These scarves are not just for church—they
can be found around their chocolate-coloured necks and
shoulders when they're in the fields, streets, markets, attending
a coffee ceremony, absolutely everywhere. There are two
weights—one lightweight for summer and a heavier one for
winter. Hand-woven, all of them. For funerals they turn
them inside out as a mark of respect.

There's nothing quite like slipping,
exhausted, between freshly pressed fine
white sheets, especially ones that carry
the smell of being dried by the sun.
Minimalist interiors have a careless
association with white, while in painterly
terms, minimalism stems from 1960s
painters, such as Sol LeWitt, who were
mostly from New York, working three-
dimensionally, often with white.

Simplify your life.

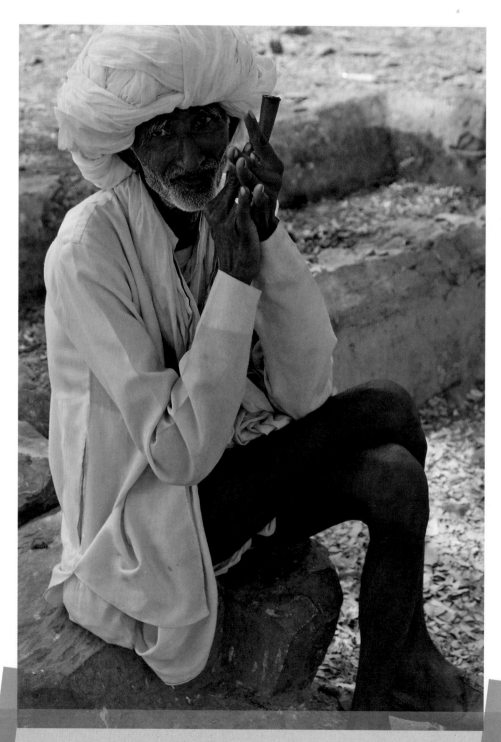

Share your hopes and aspirations. Make them happen.

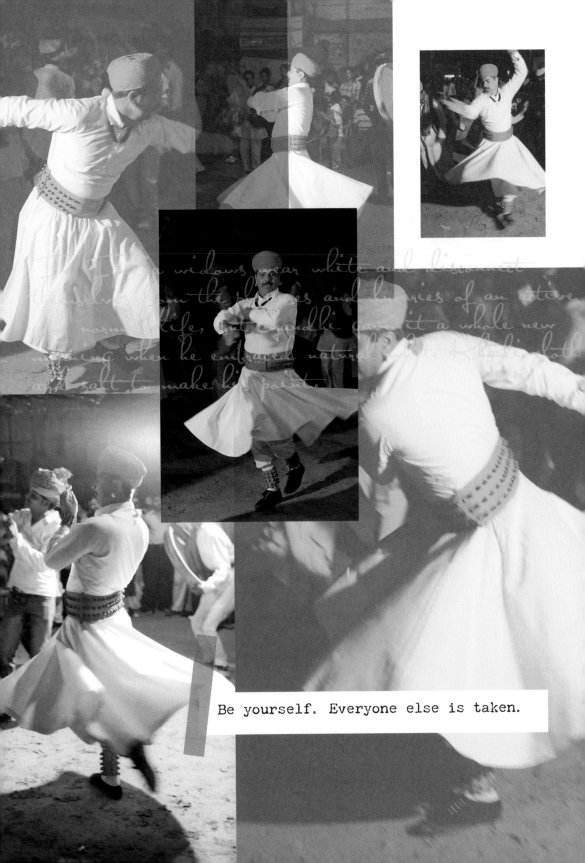

Be yourself. Everyone else is taken.

Wise up.

Traditionally an artist's canvas and other white textiles began life as a natural calico colour and were then bleached by sunlight. First came Claude Louis Berthollet's chlorine in the late eighteenth century, which led to bleaches, to be followed by optical blueing. To create a bright white and offset the natural yellow cast, a slight blue tint was added—Guimet blue for laundry and cobalt oxide for ceramic glazes. In 1929 fluorescent dyes that absorb ultraviolet light and remit blue were discovered. These improved the whiteness of commercial paper, and were added to laundry detergents.

White is versatile. We go white with fear; the Milky Way scattered across the sky fills us with awe; white rice and white bread are staples; and we declare surrender with a white flag. White is a sign of cleanliness and the symbolic colour of Yom Kippur, the Jewish Day of Atonement.

Be adventurous.

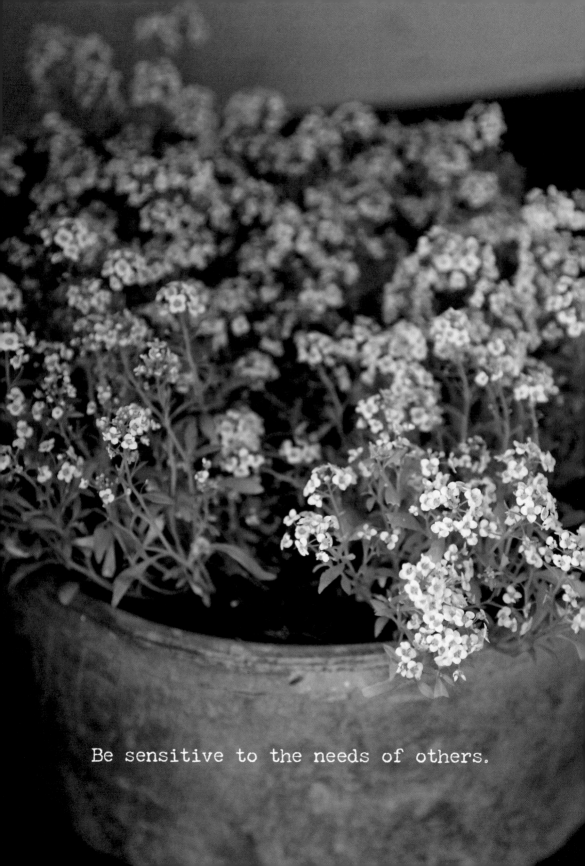

Be sensitive to the needs of others.

When a Muslim wears a *taqiyah* (also known as a *kufi* or prayer cap) under their *keffiyah* scarf, it is always white. The *taqiyah* serves as a form of religious uniform, to identify somebody who adheres to Islam. Muslims wear the *taqiyah* to emulate Muhammad, as his companions were never seen with their heads uncovered. The *taqiyah* is an ancient tradition, with pre-Islamic Arabs considering it inappropriate to go bare-headed. It is also practical clothing for the desert's hot days and cold nights.

Who doesn't love the look of whitewashed Greek houses by the sea? Most were built before air-conditioning, so they were whitewashed as an efficient means of keeping them cool. The whitewash reflects the sunlight. They remain cool to the touch, and are lovingly whitewashed up to three times a year. Their blue domes represent the sea and sky.

Versatile white paint may be made from many different bases—alabaster, quartz, rice, barium, chalk, zinc or little fossilised sea creatures found in limestone graves. The ideal support for dye or paint is white. Whatever its tone, warm or cool, it offers choice and resonates like a silence.

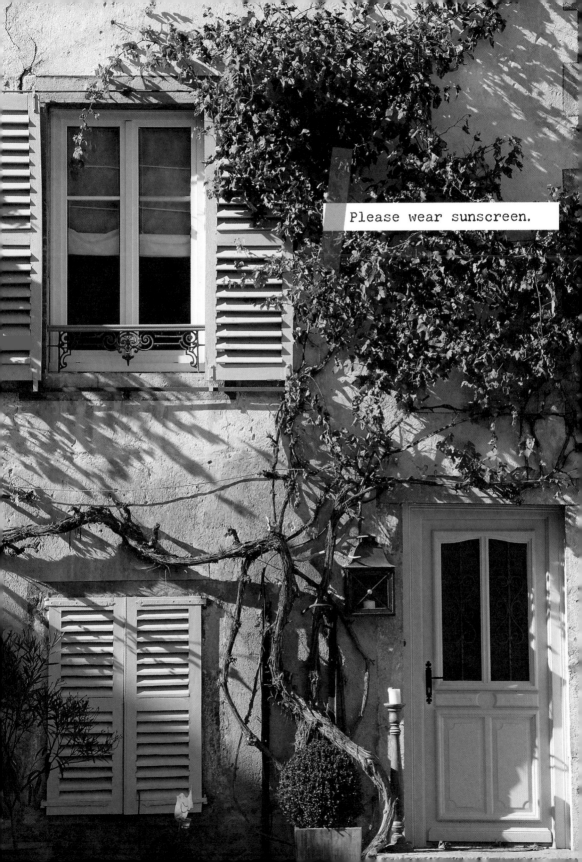

Please wear sunscreen.

Lighten up with white X Add any colour to white and it takes the hint. X Add white to any colour and it goes pale. X Look into a bowl of rice and count the whites. X Be appreciative of every sip of milk you take. X Give a white chocolate heart for no reason other than to say I thought of you. X Acknowledge food looks its very best on a white plate. X Nestle into a down feather couch, book in hand. X Treasure a natural wool sweater. X Use iodised salt, sparingly. X Make marks on a fresh white canvas. X Print your photographs onto glossy white paper and share them with a friend. X Fill a notebook with your thoughts. X Place a bunch of lily of the valley in a white jug. X Plant a magnolia. X Gaze at the Milky Way. Notice how it's warped and on the move. X Wear white. Look fresh. X Share a wheel of brie. X Dream about strolling through a Mediterranean village. X Sing along with karaoke at cherry

blossom time. X Marvel at stiff egg whites while getting a grip on making meringues. X Admire a goose. Get up close and personal. X Wear white canvas sandshoes. Forget the laces. X Ski, at least once. X Give a gift of gardenias. X Fill a room with the smell of tuberoses. X Stand on the edge of the sea and feel the waves ripple over your toes. X Post a letter in a crisp white envelope. Seal it with a kiss. X Appreciate the light at the end of the tunnel. X Kiss an angel. X String a daisy chain. Give it to someone you love. X Peel a lychee. X Own at least one white linen shirt. Let the creases tell about your day. X Value the calm inside you. X Collect eggs. Scramble them. X Reminisce about foggy country mornings. X Repetition works, just ask a wave. X A bud in half bloom appreciates a cloud. So can you. X Remember Helen Keller? 'The best and most beautiful things in the world cannot be seen or touched ... but are felt in the heart.'

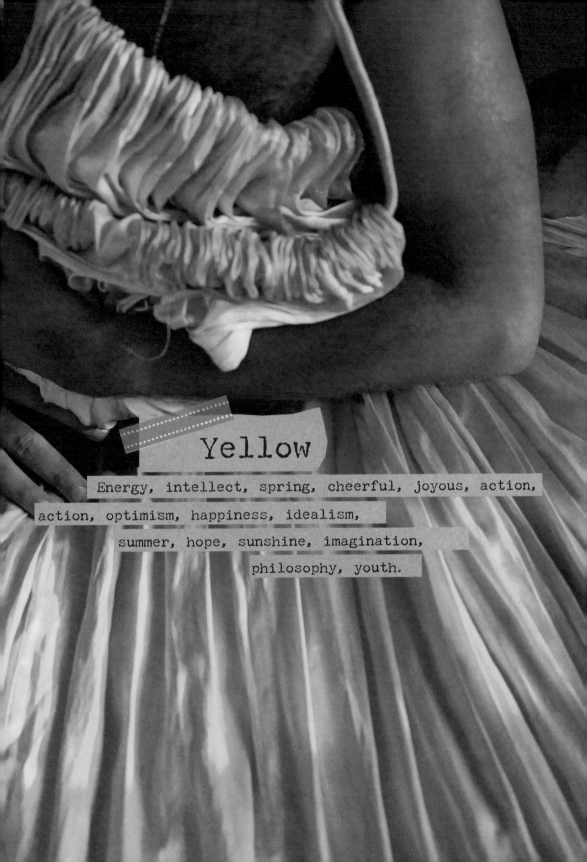

Yellow

Energy, intellect, spring, cheerful, joyous, action, action, optimism, happiness, idealism, summer, hope, sunshine, imagination, philosophy, youth.

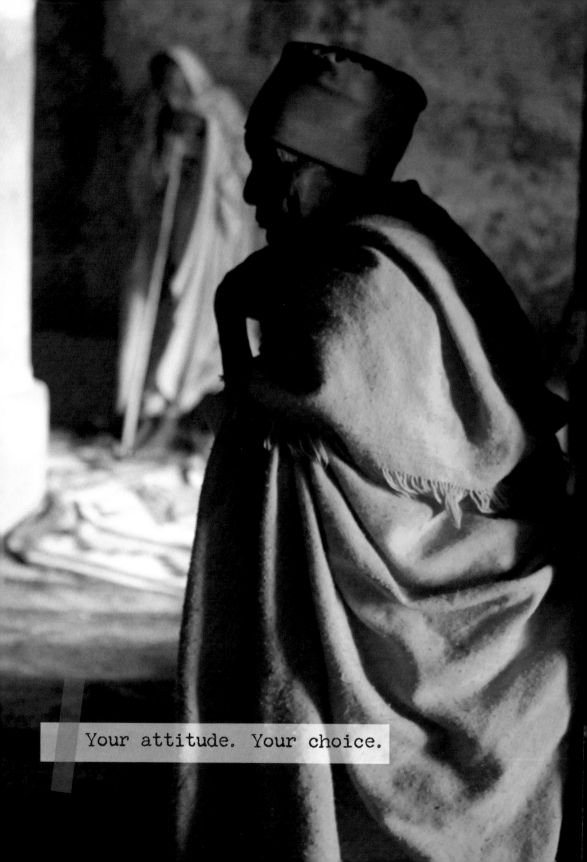

Your attitude. Your choice.

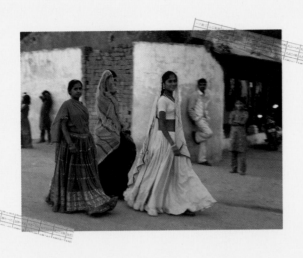

In Asia yellow has imperial and sacred significance. Attention-seeking yellow is the colour of Buddhism and many a champagne toast. A colour of extremes, it is warm but can produce negative effects. It heralds the autumn and flowers being reborn in spring; it's sacred in the East as the colour of separation, and monks' robes in Ethiopia are made of it, while in the West it's the colour of danger, capable of evoking anxiety and fear.

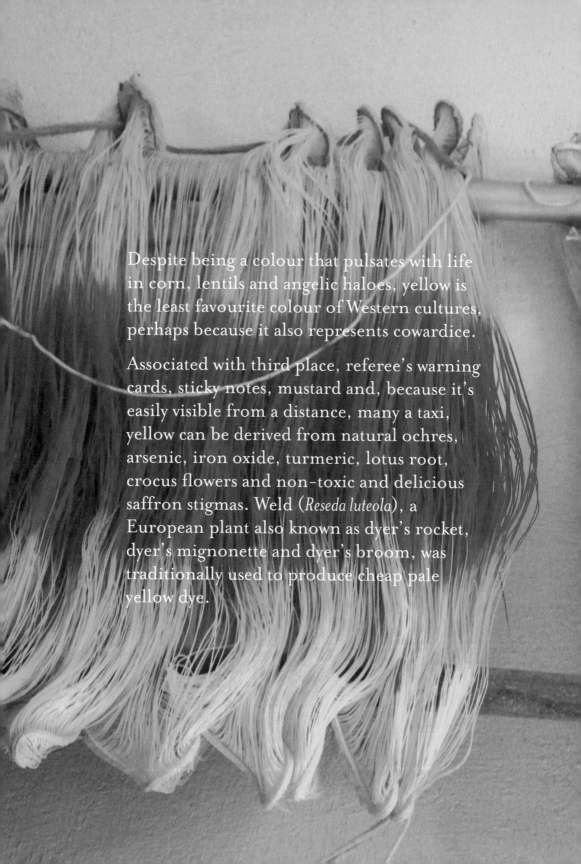

Despite being a colour that pulsates with life in corn, lentils and angelic haloes, yellow is the least favourite colour of Western cultures, perhaps because it also represents cowardice.

Associated with third place, referee's warning cards, sticky notes, mustard and, because it's easily visible from a distance, many a taxi, yellow can be derived from natural ochres, arsenic, iron oxide, turmeric, lotus root, crocus flowers and non-toxic and delicious saffron stigmas. Weld (*Reseda luteola*), a European plant also known as dyer's rocket, dyer's mignonette and dyer's broom, was traditionally used to produce cheap pale yellow dye.

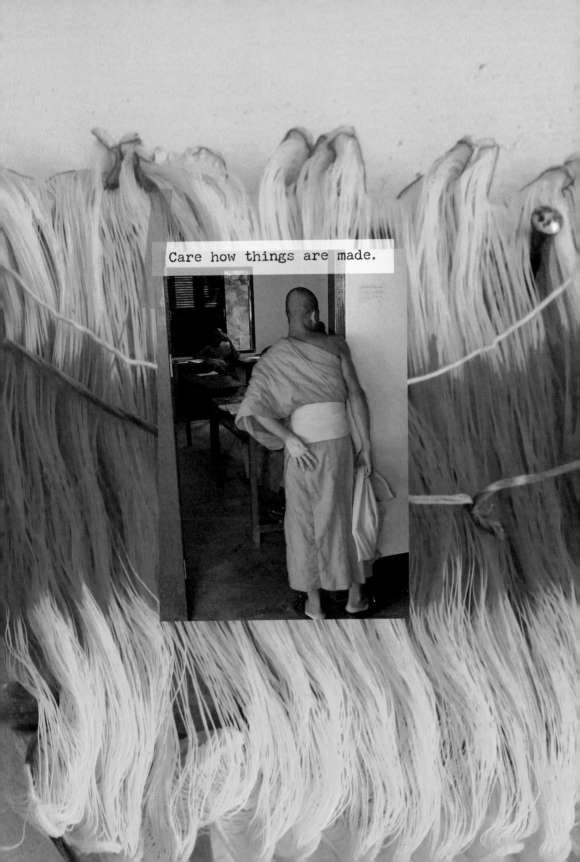

Care how things are made.

The word 'yellow' comes from the old English word
geolu. In Japan it's the colour of courage, in Egypt
the colour of mourning, while in American slang a
coward can be called yellow–bellied. It has rarely
been used for political reasons or in flags, except for
quarantined ships. The plant world is full of it, and
most plants that contain yellow pigment can be used
to make dyes. The Turks used chamomile and West
Africans certain types of mushrooms but the Aztecs
preferred dahlias.

Fifty thousand years ago, in Arnhem Land in Northern
Australia, the oldest known cave painting was traced in ochre.
Since then yellow ochre has been bound with egg yolk, wild
orchid sap, wax and resin, and used in Aboriginal paintings
made on eucalyptus bark and the body.

In the third millennium CE, the ancient Egyptians began using
yellow pigments—in particular a toxic mineral orpiment or
arsenic found in the Sinai desert and Asia Minor—to decorate
funeral chambers and sarcophagi. They appreciated the way the
grains captured the light. During antiquity Greek and Roman
painters used orpiment in abundance; in the nineteenth
century it was banned as a harmful substance.

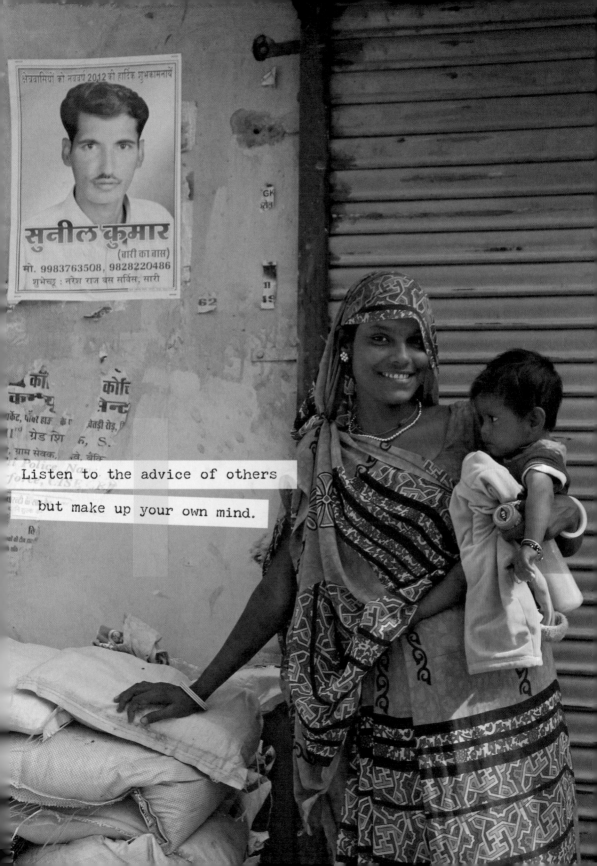

Listen to the advice of others
but make up your own mind.

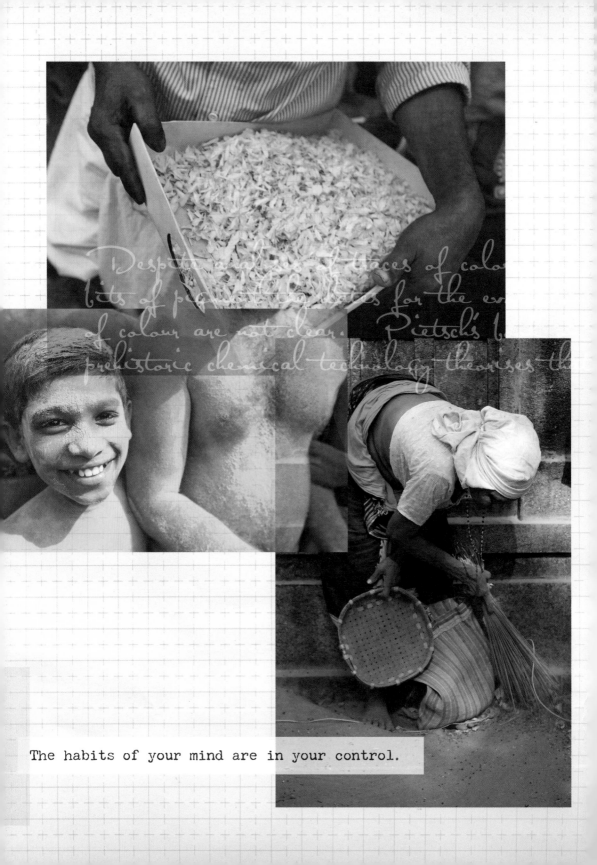

The habits of your mind are in your control.

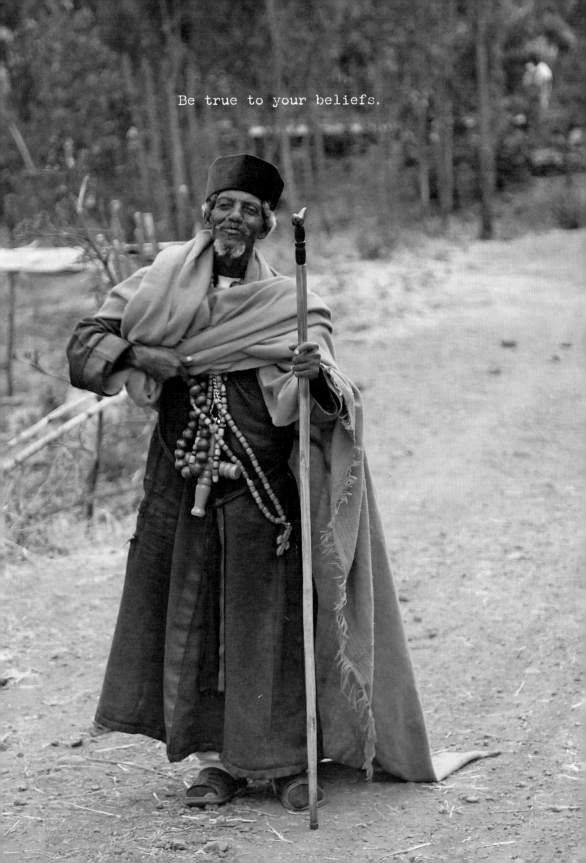

Be true to your beliefs.

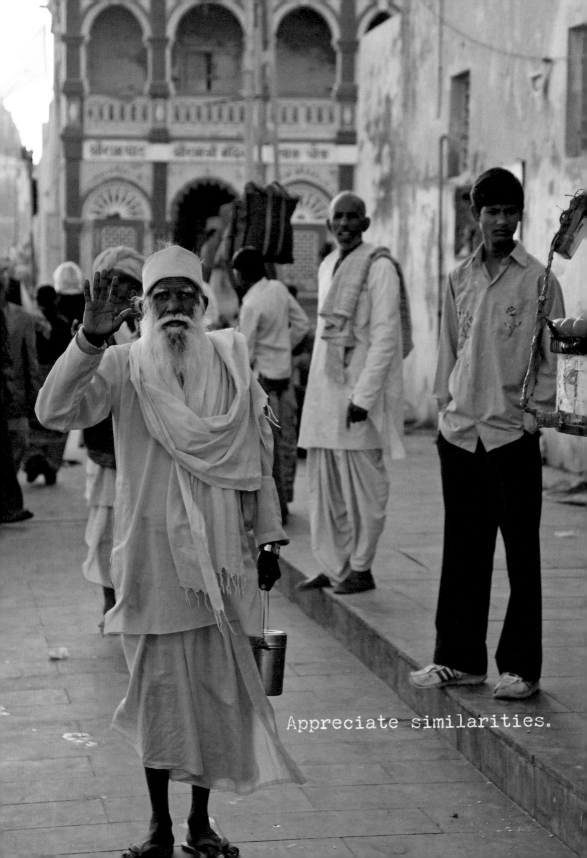

Appreciate similarities.

Yellow has nuances like no other colour. The Indians loved it for their mural paintings, and the Chinese remained faithful to it in their traditional paintings. They also used orpiment to help retard hair loss. In ancient China only emperors could wear sunshine robes, as yellow was associated with rebirth and symbolised the centre of the earth. Fabrics were embroidered with gold and manuscripts laden with golden letters.

The colourfast dye produced from saffron, the dried stamen of the oriental or Mediterranean crocus (*Crocus sativus*), was imported into Europe and used only to dye the clothes of the wealthy. Have you ever wondered why saffron is so expensive? It's because it takes about 700,000 blooms collected by hand to make 500 grams of saffron. Native to southwest Asia, each plant produces only about four flowers. It was first cultivated in Greece.

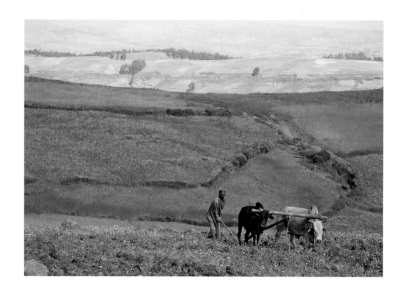

When used with white, yellow was the Christian colour for Easter but, conversely, Judas Iscariot is often portrayed wearing yellow as it is also associated with envy, greed and treachery.

As early as 1270 there was anti-Semitic feeling in England, and King Edward I decreed that the Jews were a threat to the country and must wear a yellow star to identify themselves in public.

Think of van Gogh's later works and you think of yellow. During the Italian Renaissance, Leonardo da Vinci praised yellow as the colour of light, and painters have been making round yellow spots to represent the sun for ages. With their golden yolks, chooks have provided us with one of the most versatile ingredients for cooking.

Refuse to be boxed.

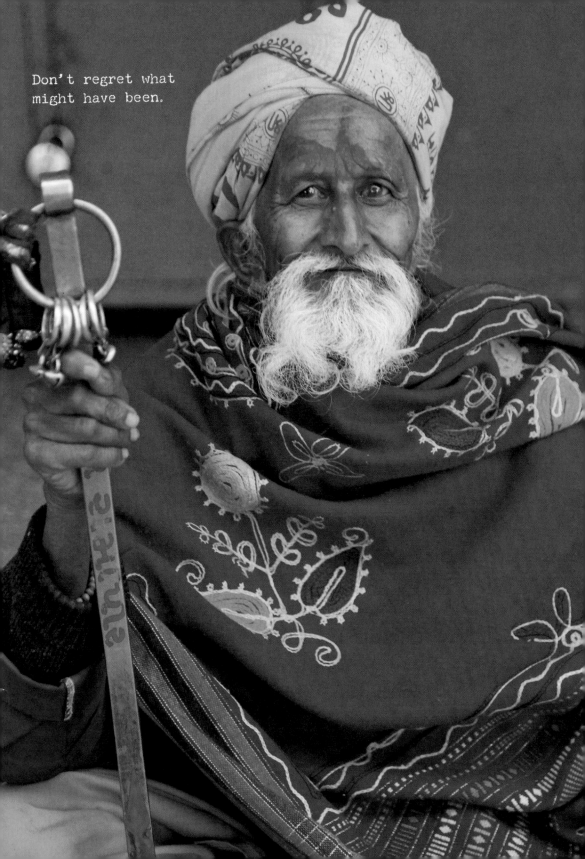

Don't regret what
might have been.

一	二	三					八	九
一一如一	二一如二	三一如三				如七	八一如八	九一如九
一二如二	二二如四	三二如六				十四	八二一十六	九二一十八
一三如三	二三如六	三三如九				一	八三二十四	九三二十七
一四如四	二四如八	三四一十二				十八	八四三十二	九四三十六
一五如五	二五得一十	三五一十五				十五	八五中四十	九五四十五
一六如六	二六一十二	三六一十八				十二	八六四十八	九六五十四
一七如七	二七一十四	三七二十一				十九	八七五十六	九七六十三
一八如八	二八一十六	三八二十四				十六	八八六十四	九八七十二
一九如九	二九一十八	三九二十七				十三	八九七十二	九九八十一

A B C D E F G H I J K L M
N Z

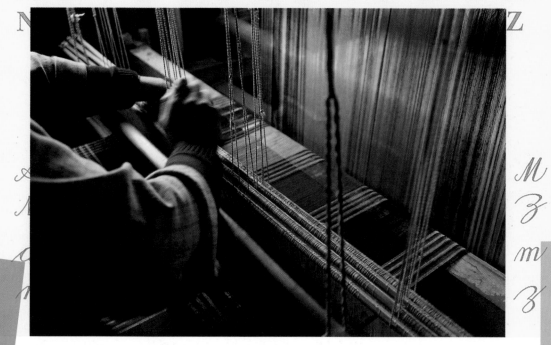

Your biggest chance for change is contained within your mind.

In Asia and the Pacific Islands, yellow is considered honourable, and is associated with happiness, the gods and power.

Yellow's positive attributes are profoundly inscribed in Indian civilisation, where it symbolises vibrant sexuality and fertility. Yellow is connected with marriage, with turmeric playing an essential role. The root is used to colour and purify the wedding food, sprinkled on invitations and gifts, and smeared on the couple's skin to bring them wealth, health and many children. Single women and widows touch the newlyweds to benefit from the good auguries. Turmeric pigment is also believed to combat illness and is used in rituals.

Yellow is one of the strongest colours, brilliant and resolute; psychologists recommend it as the colour of confidence, one that helps overcome shyness. A symbol for the desert, the sun, gold and the colour of money, honey, hazard and risk, cheerful and aggressive yellow is stimulating no matter what form it takes. It's an appropriate colour for a room used for studying. A bright shot of yellow gives a warm flash. Yellow may sometimes be avoided when warning of hazards, but is at its best when admired.

Appreciate what's before you.

If you belong there is no need to declare it.

Treat another's heart as you would your own.

Beautiful should also be useful.

Go the distance with yellow X Make hay
while the sun shines. X Think of glow-worms
and smile. X Spice up your cooking with
turmeric and saffron. X Don't drink and
drive. Think comfy yellow taxi. X Gather a
bunch of daffodils and bring sunshine into
your life. Or give some to another. X Do get
vaccinated against yellow fever. X Squeeze
a lemon and marvel at its versatility. Zest
one and be grateful for its tang. X Enjoy the
sun shining on your back. X Look lovingly at
faces warmed by candlelight. X Think classic
yellow. Learn from *National Geographic*. X
Knit a soft and warming Naples yellow scarf.
X When you cook appreciate the many steps it
takes to make your butter. Never forget it.
X Wonder at the value of old and yellowed
documents. X Admire a monk's saffron robes.
X Know Kodak would not have been the same
without its packaging. X Look lovingly at
Monet's haystacks and be reminded of the
impermanence of green grass. X Chase a

yellow tennis ball around a court. Or throw
one for a dog. X Wonder why canaries are
yellow. X Remember the once useful *Yellow
Pages*. X Visit Yellowstone National Park. X
Peel and eat a banana. X Watch *The Wizard
of Oz*. Marvel at the yellow brick road. X
Dream of yellow submarines. X Gently stir
some custard. X Look at the stars. Really
look. They shine for you. X Play merrily with
Dinky toys. X Don't be a coward, or mix with
one. X Pull on your yellow gumboots and play
in a puddle, or play with a child who does.
X Travel to France and post a letter in a
yellow postbox. X Leave a surprise little
yellow love note. X Plant sunflowers and
watch them turn towards the sun. X Place a
buttercup under your chin. Make it glow. X
What's not expressed will be depressed. Help
a canary sing. X Love a labrador dog. X Play
spot the lion in the wild. X The sun cannot
withhold its light. Neither should you. X
Dream of beehives and golden honey.

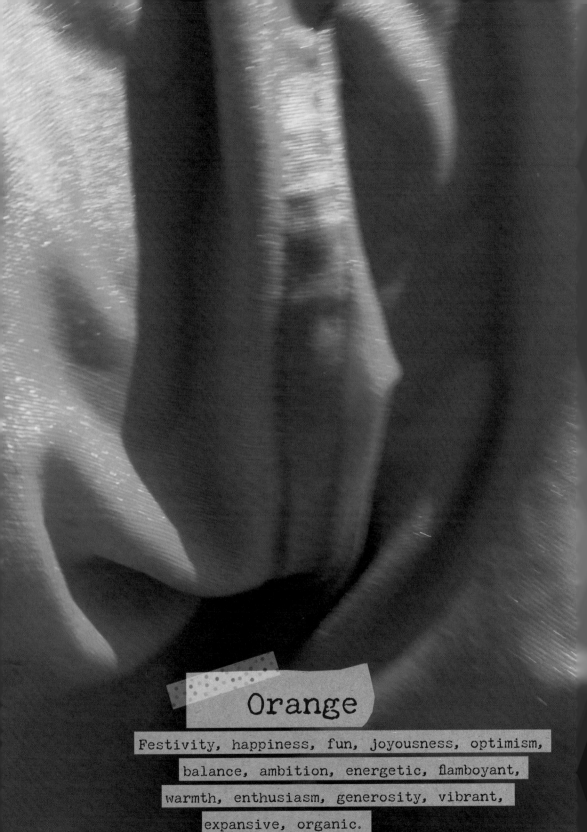

Orange

Festivity, happiness, fun, joyousness, optimism, balance, ambition, energetic, flamboyant, warmth, enthusiasm, generosity, vibrant, expansive, organic.

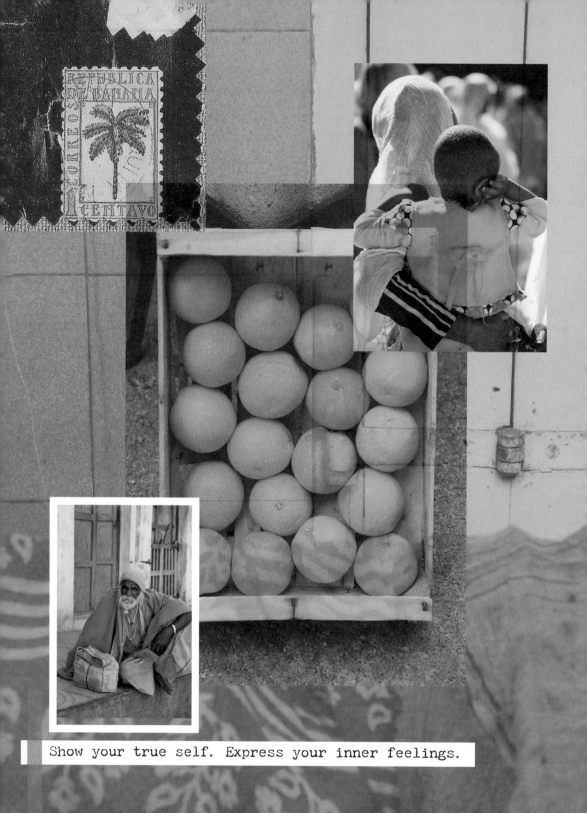

Show your true self. Express your inner feelings.

Most often thought of as a mixture, a blend, a convergence of red and yellow, orange gives off a feeling of joy and is associated with optimism, festivity and happiness.

Historically and culturally, orange cloth, originally saffron-dyed, has long been one of the colours of Hinduism. In India saffron robes have been worn for religious reasons for more than 2000 years. It's not surprising then that the first thing that comes to mind when we think of orange is Buddhist monks in India, Thailand, Sri Lanka or Laos, or perhaps Hindu worshippers. Waking up to monks walking the narrow streets of Luang Prabang in Laos to collect alms in a quiet, orderly single-file procession is a humbling, memorable and colourful travel experience. Christian pilgrims also wear orange in South India and, in doing so, teach us that no one owns a colour.

For some time now I've travelled with an orange suitcase, chosen originally because it was easy to spot on a baggage carousel among a sea of black ones with a sameness about them, and also because I felt it protected me from someone taking my suitcase by mistake. As time has passed I've realised this happy difference makes others feel good too. It's a cheery point of difference at check-in counters. With a gentle tone, and perfect French accent, a Peruvian-born taxi driver told me on the way into Paris: 'Did you know in India orange is a very good colour for the head and the heart?' My reply: 'I certainly do. But that doesn't just apply to India.' I've never had a bad time while wearing orange. It's an energetic, fun colour.

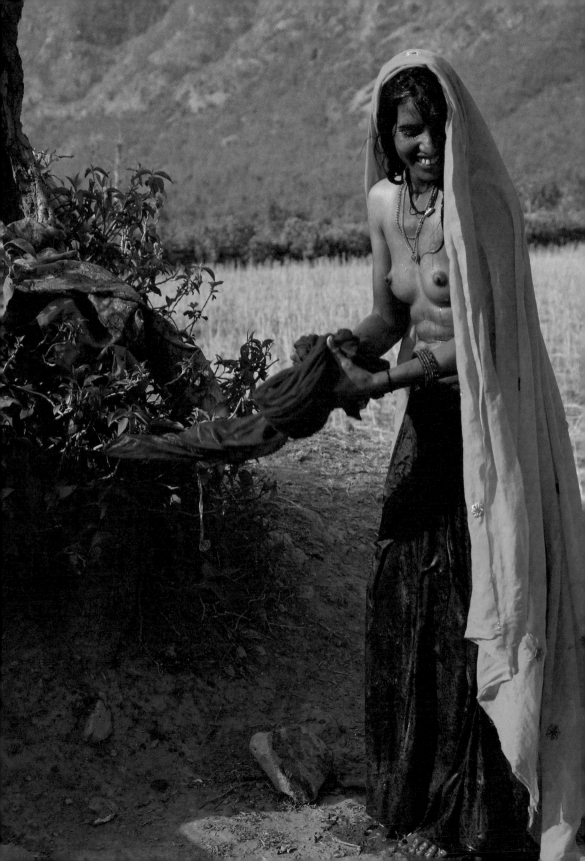

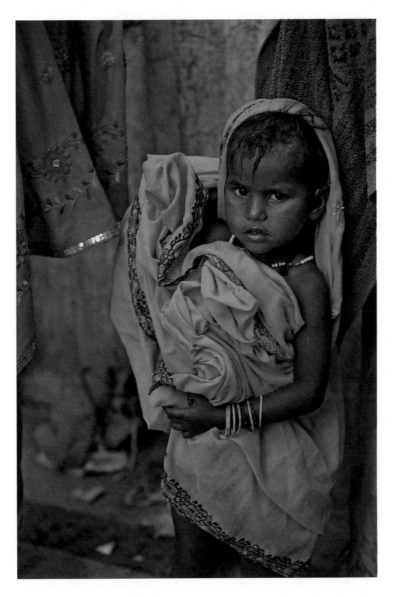

Nothing can be understood without an historical understanding.

There's nowhere to hide.

The first recorded use of 'orange' as the name of a colour in English was in 1512, and it will probably come as no surprise that it is actually named after the ripe orange fruit. Seems they're inseparable. Before this it was known as geoluhread *(yellow-red).*

The Russian painter Kandinsky said, 'Orange is red brought nearer to humanity by yellow.' For the Japanese and Chinese it's the colour of love and happiness, and represents energy and balance. The Greeks and Romans also appreciated its warm tones and its luminosity, but nothing quite matches Nero's gesture in the worship of orange. During his reign in the first century CE, only the richest patricians could afford saffron-dyed textiles. Nero scattered saffron over the streets of Rome to show the plebeians a sense of refinement, one usually reserved for the nobility. It won him popular support.

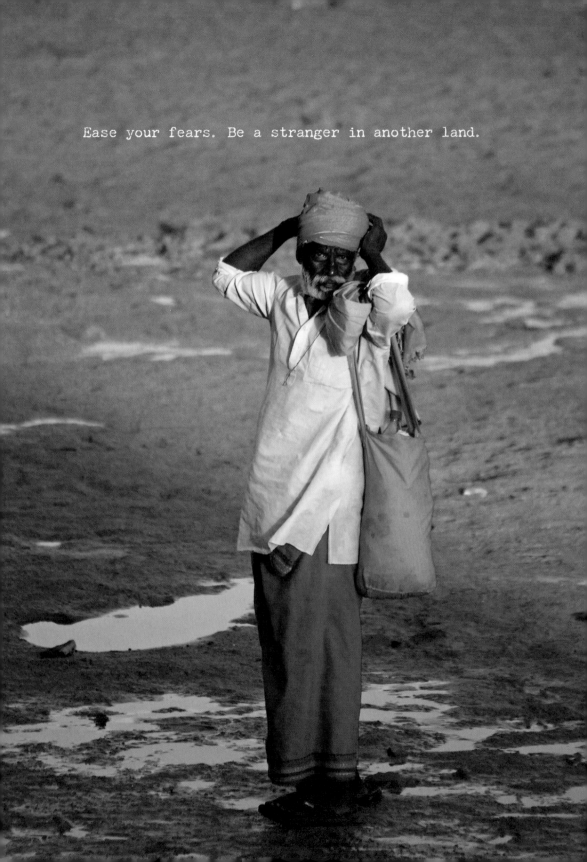
Ease your fears. Be a stranger in another land.

Follow your bliss.

Dare to be original.

Orange has been adopted in some American jails as the colour of inmates' uniforms, hopefully adding some cheer to an otherwise grey life. It's the colour of safety that so often announces road hazards.

The flag of New York City, formerly the Dutch-controlled New Amsterdam, is orange, blue and white. It's based on the former flag of the United Netherlands.

Orange is the national colour of The Netherlands. Their royal family, the House of Orange-Nassau, derives part of its name from its former holding, the principality of Orange. The title Prince of Orange is used by the Dutch heir apparent, and orange is the Dutch festive and, often, sporting colour. In Thailand orange is a symbol of Thursday.

The smell and taste of mangoes ripening marks the beginning of summer. Likewise the fragrant ripening of mandarins heralds a change of season.

When oranges change their colour from green to orange, it's not an indicator of ripeness because the rind can turn orange long before the fruit is ready to eat. Tasting them is the only way to know whether they are ripe.

To change your life, start immediately.

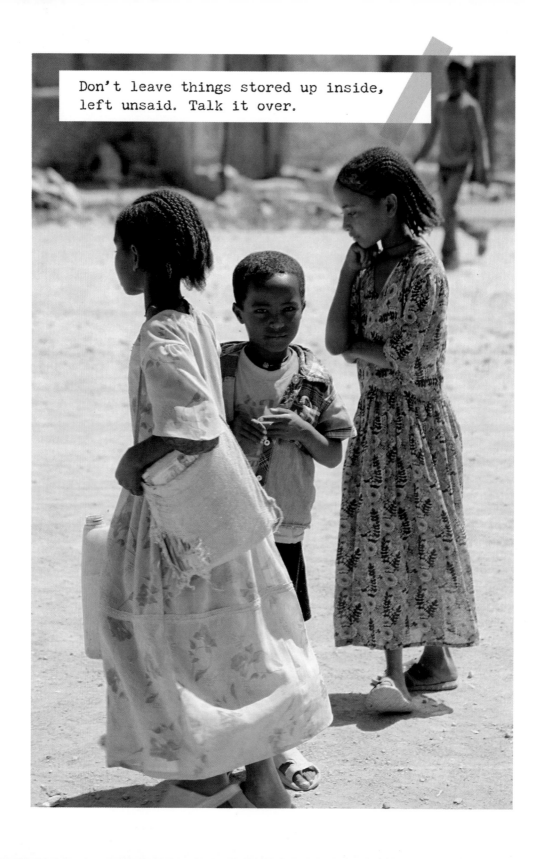

Don't leave things stored up inside, left unsaid. Talk it over.

Thought to have originated in Southeast Asia and cultivated in China by 2500 BCE, juicy, round oranges are renowned for their concentration of vitamin C. They are the most commonly grown fruit in the world.

Best grown in tropical and subtropical climates—but if covered they're adaptable to frosty conditions—they're available from winter through summer, and seem to taste of the sun. Orange trees thrive in consistently sunny, humid environments, and need fertile soil and adequate rainfall or irrigation. Versatile, sweet and sour, peeled or cut, eaten whole, quartered, juiced or zested, oranges are a complete ball of joy.

Learn from others' ways.

Clarify your values and live by them.

SEP 2001 C. 1

Pol ol
Col

15 Oct 59

Nov

15 De

AG 1 '6

23 62

Look for the positives.

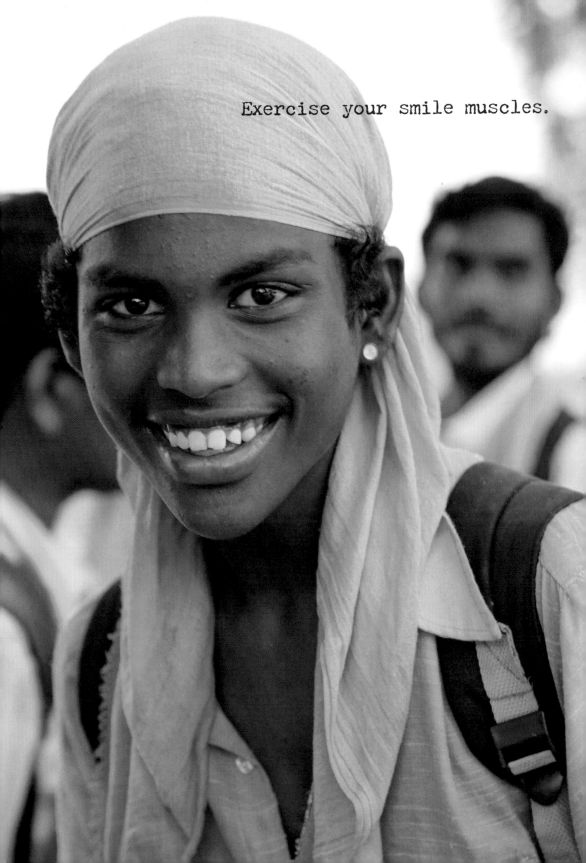

Exercise your smile muscles.

Juicy Orange X Take time to appreciate a full moon. Or any other one. X Make a marigold necklace. X Bake a flourless orange and almond cake. X Squeeze chilled oranges for their juice. Don't strain it. X Dance freely among autumn leaves. X Visit Orange County. X Be bold. Warm yourself with an orange scarf. X Celebrate Halloween. It's not just for kids. X Dissect a mandarin. Share it. X Stare into the flames of an open fire. Spot the difference between the orange and red flames. X Taste test the difference between a 'Navel' and a 'Valencia' orange. X Acquaint yourself with Uluru. Stay a few nights. X Explore the ochre pits. X Smell some orange blossom. X Plant canna lilies. X Look for orange coral. X Relish a mango. X Feed a carrot to a rabbit. X Be sweet to a sweet potato. X Make orange marmalade. X Light candles in jars. String them with wire and hang them in your trees. X Fly an orange kite. X See orange in the hands of a master. View Cezanne's tabletops. X Cover

a photograph album with orange to remind
yourself of the joy of a holiday. X Sip a
bellini. Share one with a friend. X Show your
appreciation for the fewer than 4 per cent of
people who have red hair. They're mostly in
Ireland, England and Australia, and are not
all bad-tempered and covered in freckles. X
Go deep-sea diving and spot an orange roughy,
also known as deep sea perch. X Stick cloves
all over an orange to make a pomander that
will keep the moths away. X Pick up a vintage
Penguin. Be grateful to Allen Lane, who
wanted something decent to read on the train.
X Give someone a string of amber beads. X
Visit a Buddhist temple. More than once. X
Understand Hinduism. X Find new ways to cook
with turmeric. X Watch goldfish. X Watch
A Clockwork Orange at least once. X Help save
the orangutans, and learn about their life
in the rainforest. X Make apricot conserve
and turn it into a tart. X Juggle. X Catch a
sunrise and a sunset. Compare the difference
in the sun's glow.

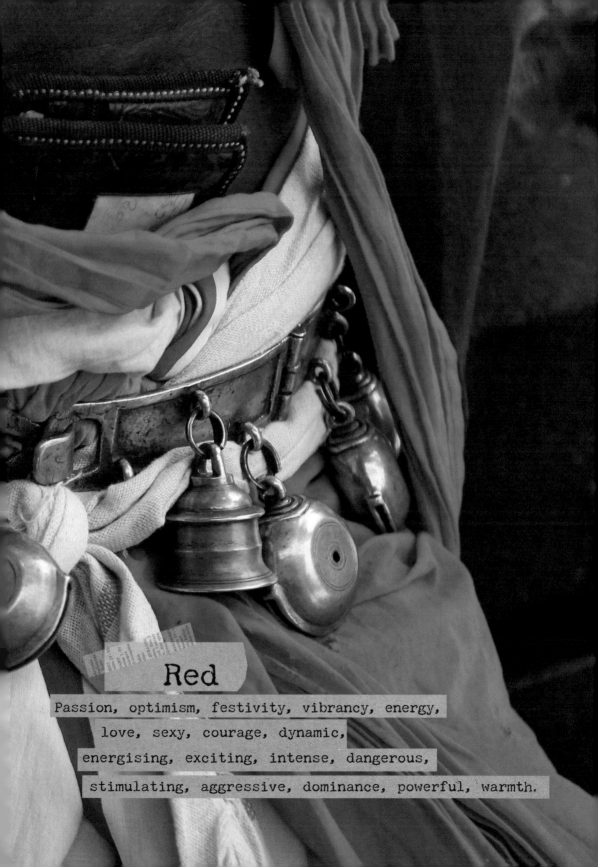

Red

Passion, optimism, festivity, vibrancy, energy,
love, sexy, courage, dynamic,
energising, exciting, intense, dangerous,
stimulating, aggressive, dominance, powerful, warmth.

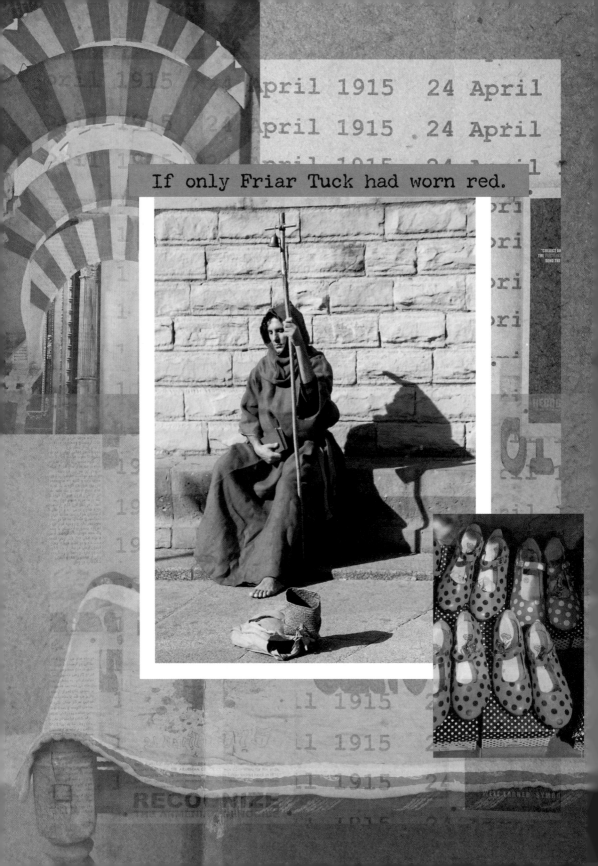

April 1915 24 April

April 1915 24 April

If only Friar Tuck had worn red.

Red, the colour of the earth in
many ancient myths, can be used to
create excitement, invoke urgency
or make your room feel like a
cocoon. But above all, warm red is
the colour that represents strength.

According to Hebrew tradition,
Adam, the name of the first man,
means red and alive. Red's the
colour of life, your blood, your
heart, so it's no surprise that in
Polynesia too the first living being,
a woman, was made by a god from
the red sand of the island's shores.
In Tibet the gods made man with
red skin; many other cultures use
red ritualistically in ceremonies that
relate to creating and sustaining
life, something worth celebrating.
It's little wonder red is the colour
of love, passion and romance.

Red is the scarlet face of both good and bad embarrassment, and is used for burial clothing in Madagascar and by brides in Bangladesh. In East Asian stock markets red is used to denote a rise in stock prices, whereas in North American and other markets it is used to denote a drop. It denotes a debt. The ancient Egyptians considered themselves a red race and painted their bodies with red dye to emphasise this. In ancient Rome they wore red clothes to protect themselves against measles, and pressed red fabric against their wounds to help stop haemorrhaging.

Closely associated with some deities in Shinto and Buddhist traditions, statues in Japan are often decked in red clothing or painted red. The Japanese made offerings of red paper origami to Shinto divinities to avert smallpox.

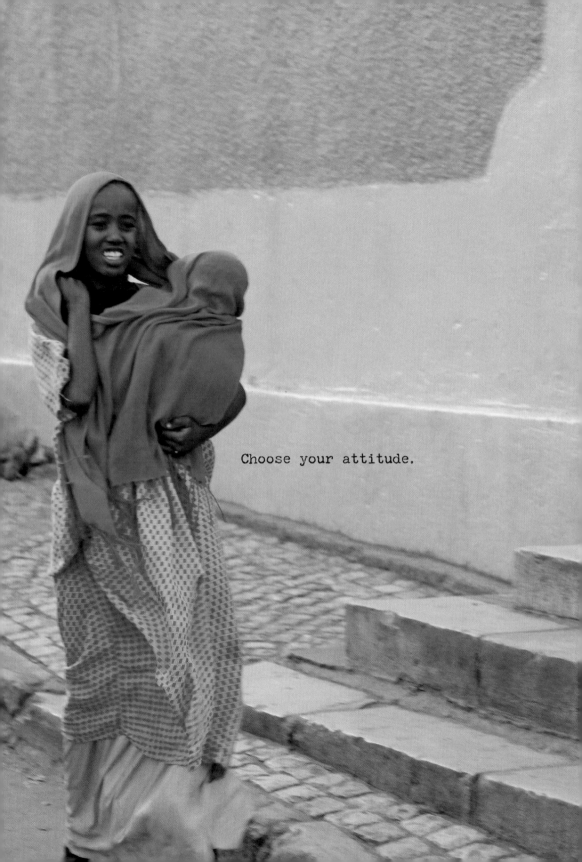

Choose your attitude.

Treat yourself as you would others.

Take time out just for you.

In Japanese folklore, red is the colour for expelling demons and illness. It's the symbol of life and the traditional colour for writing the letter that ends a relationship. Their connotations for red include complete and clear, and a red lobster, a symbol of long life, is a common gift at New Year.

Kanreki, return to the calendar, is an important celebration in Japan that marks a person's sixtieth birthday and rebirth, a return to their second childhood. The Japanese wear red to symbolise this rebirth. According to their lunar calendar, a person turning sixty will have gone around the twelve animal years of the Chinese zodiac five times, completing a cycle of life on this earth. The cycle then returns to the beginning. Babies too wear red in Japan, as they are embarking on the next sixty-year cycle.

Exercise. Respect your knees.

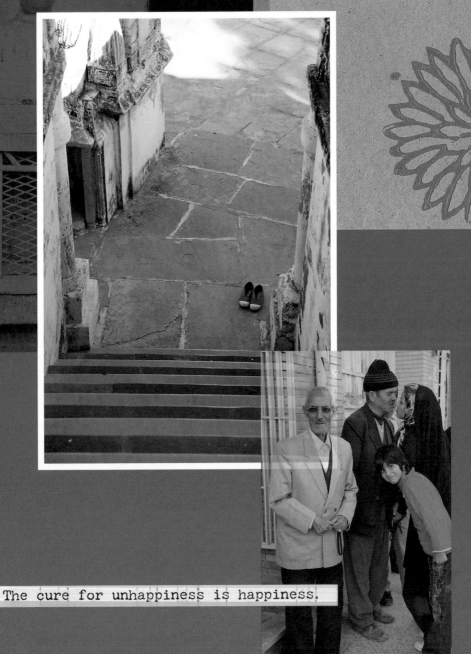

The cure for unhappiness is happiness.

Hang out with like-minded people.

There is nothing more valuable than family and friendship.

The Chinese have more than thirty symbols for different kinds of red and even more terms to describe the shades of red, so it's no surprise they consider red a revitalising colour. Red signifies good luck and happiness and is omnipresent in Chinese marriages, but did you know it is also traditionally associated with pomegranates, whose seeds symbolise a rich line of descendants?

Throughout the Far East, red plays a role in happy occasions and is perceived as the dispenser of life. In Thailand it is a symbol of Sunday, and in Buddhism the extinction of desire.

The Russian word for red, *krasniy*, originally meant 'beautiful'. In the Slavic family of languages, red denotes living and beauty, and who could not like the idea of red sharing a common root with the words for joy, hilarity and love, as it does in the Indian language?

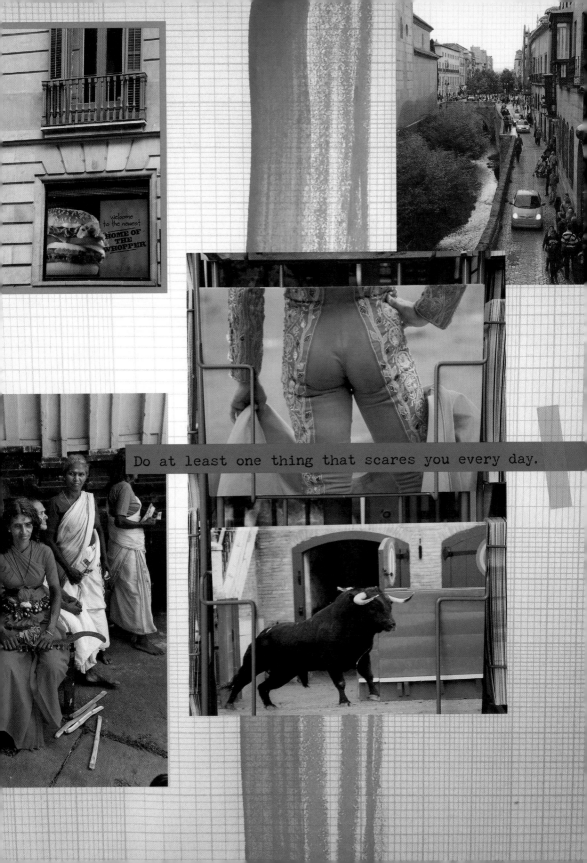

Do at least one thing that scares you every day.

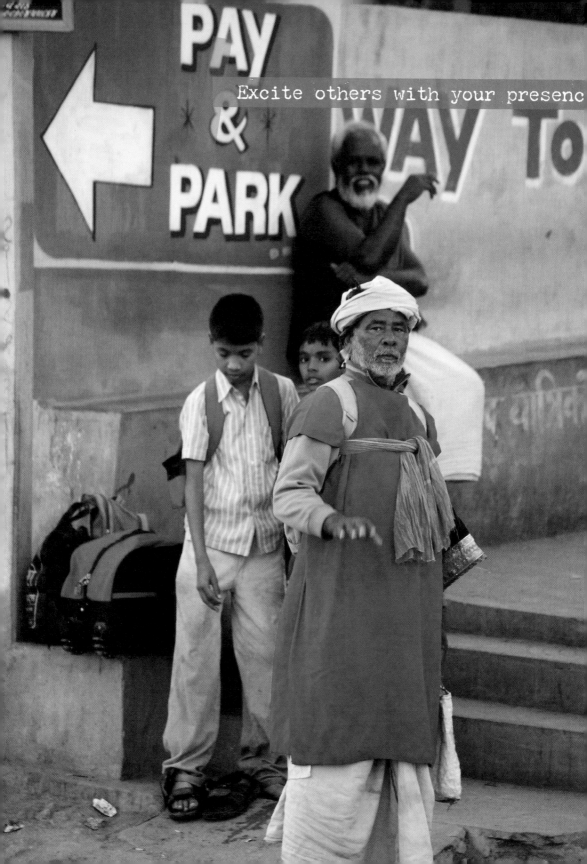

Excite others with your presenc

An Indian bride wears a red sari given to her by her father, signifying the hope of a fertile marriage and that he passes responsibility for his daughter's care to her husband. The female members of the groom's family paint her hands and feet with ritual red ochre and sandlewood to bring happiness and strengthen the status of the bride. She wears a red *bindi* or *tikka* on her forehead to demonstrate her marital status. Grooms wear red turbans. Traditional brides in Indonesia and China also wear red, and Japanese brides wear a red kimono after the formal wedding ceremony. In Nigeria only chiefs wear red.

Red marks honour; we roll out the red carpet and drape red bunting for celebrations. The red hibiscus is the national flower of Malaysia, where it's used for herbal medicine. For the Cherokees of North America, red is symbolic of victory. In the Upper Great Lakes region, there was once a custom of red ochre burials. For the New Zealand Maoris, bright red is a sacred colour. Italians give bright red underwear to be worn for luck on New Year's Eve.

Red makes an appearance on many a flag, including the red star that became the Communist emblem, and appears in the centre of this book—in China and India a line of red characters is inserted in the middle of the printed black ink text to protect the readers from the wicked spirits that could emerge from its pages.

Found on certain plants, cochineal is a parasitic insect whose shell yields excellent dyes in a full range of fine, light and water-fast reds. In 1467 Pope Paul II decreed that cardinals' robes, formerly purple, would be dyed with cochineal red.

It is comparatively easy to dye animal fibres red, and red wool is to be found in cultures worldwide, but dyeing cotton and other vegetable fibres red is more difficult. Until the seventeenth century only clever India knew how to do it.

Red has brightened up many a military uniform, and is especially effective when soldiers are on parade during peace times. It has also been practical for hiding bloodstains during war, and there was a time when the British purchased the red dye for their uniforms from their foe, Spain.

A red door means welcome and also announces the house is paid for. In Feng Shui a red door symbolises the mouth of the home. By painting a door red, or a bright colour that stands out, *chi* (positive energy) is drawn to the house and the door becomes the entry point for abundance and opportunities. In China many doors are given a fresh coat of red paint just before the Chinese New Year to invite good luck and happiness. In Ireland, a red door is supposed to ward off ghosts and evil spirits. In Catholicism the story is not so cheery—a red door represents the blood of Christ, and the area beyond the door is holy and sacred.

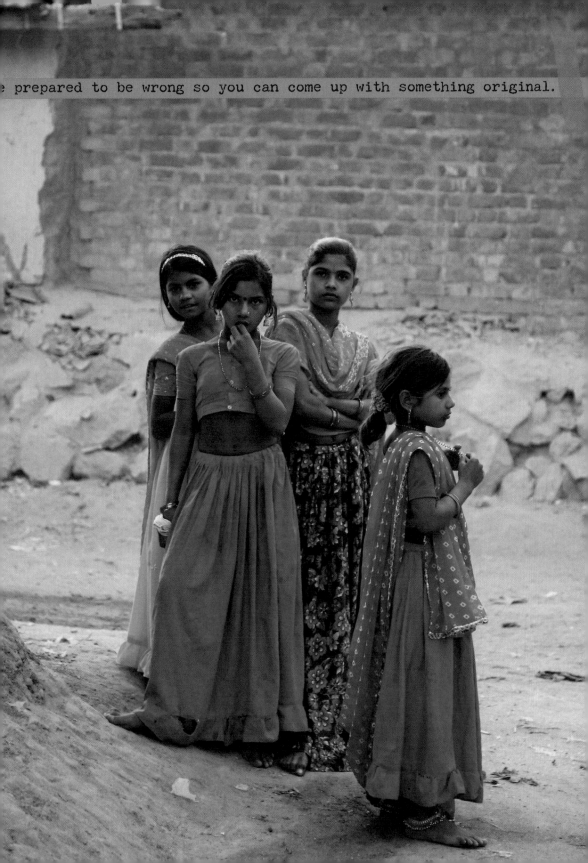

prepared to be wrong so you can come up with something original.

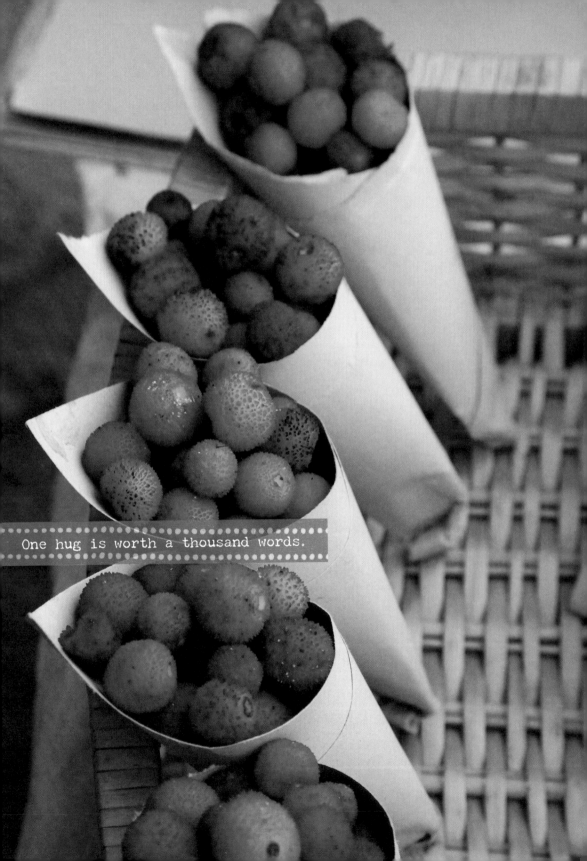

One hug is worth a thousand words.

Choose a flattering hairstyle.

In the Old Testament the Jewish slaves in Egypt smeared their doors with lambs' blood—a sign that the required sacrifice had already been made—in the hope their homes would be passed over by the Angel of Vengeance. The Underground Railroad, a covert American movement that helped slaves flee to freedom during the 1850s, used red doors to flag the safe houses. Albert Einstein painted his door red so he could easily recognise his house.

We can be 'red-blooded', a 'red-neck', 'be caught red-handed' and be 'in the red'. Red has endless shades, tones and associations. Do you too remember the healing effect of Mercurochrome? There's the innocent red of childhood, the red as you shut your eyelids, the red on many a bird's wing or a flower petal, the red Caravaggio used in painting after painting, the red heart by which you swear your passionate love, the vital red that runs through your veins, ruby red, coral red, Santa's clothes, cardinal red, lipstick red, letterbox red, London bus red, fire-engine red, Canadian Mountie red, and the red that says 'stop'.

Let's honour red by eating an apple a day to keep the doctor away and wearing a red ribbon to help raise awareness and money to fund research to find the cure for AIDS.

Seeing Red X Set red sails in the sunset.
X See every day as a red-letter day. X
Paint your nails red, or admire someone
who has. X Roast freshly picked beetroots.
X See a ladybird safely home. X Blush.
Just because you can. X Pay your bills on
time. X Plant a paddock of red poppies. X
Support the Red Cross. X Wonder where we
would be without infrared. X Marvel at the
red in Philip Guston's paintings. X Own
at least one red chair. X Brighten your
day with bowls of cherries or peppers. X
Eat the red jelly beans first. X Sip red
wine slowly while admiring its colour and
maker. X Snuggle under a red rug. X Gather
around an open fire. Cook on its embers. X
Consider how many people have chased a red
ball around a cricket field. X Learn about
redback spiders, then avoid them. X Marvel
at pomegranates. X Understand red ink isn't
just for corrections. X Befriend a redhead. X
Obey red lights. Vehemently. X Begin the day
with raspberries. They're low in fat, carbs
and kilojoules and high in fibre, vitamins,

minerals and antioxidants. X Look after your heart. X Congratulate yourself on your red face after exercise. X Have you ever heard the song 'Red Red Wine'? X Box and wrap a gift in red. X Go on, add a chilli. String a row of them together to hang in your kitchen. X Choose family as your friends; they're your life's blood. X Pull on a pair of red-hot socks. X Cellar some red wine for later. X Giggle with a clown. X Wear red to a wedding. Make their day. X Read *Little Red Riding Hood* all over again. X Listen to the British band Simply Red. X Carry a red bag. X Kiss a tomato. X Satisfy your curiosity. View a red panda in the flesh. X Be bold, wear red in Russia. X Blanket stitch the edge of a cushion in red. Any old cushion. X Red sends a message of joy. Add a little to your wardrobe today. X Small red cars are groovy. Just ask anyone who drives one. X Any flowers look good in a red vase. X Take time out in red and white spotted pyjamas. X File using red folders. Cheer up your desk. X Remember Mao's Little Red Book? Make one of your own.

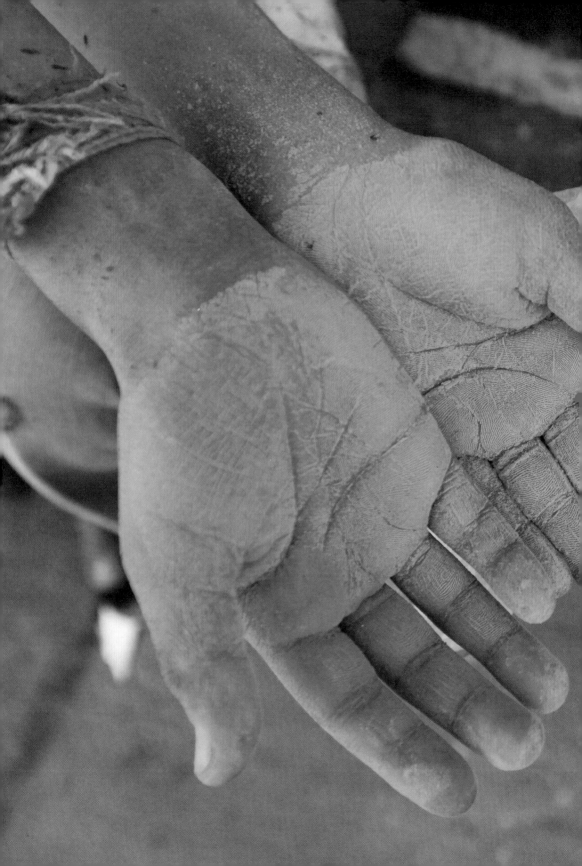

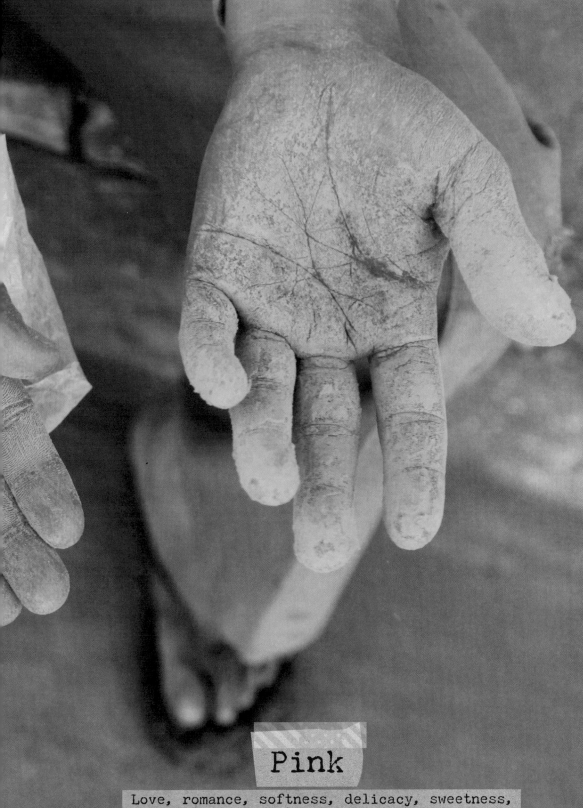

Pink

Love, romance, softness, delicacy, sweetness, friendship, tenderness, fidelity, compassion.

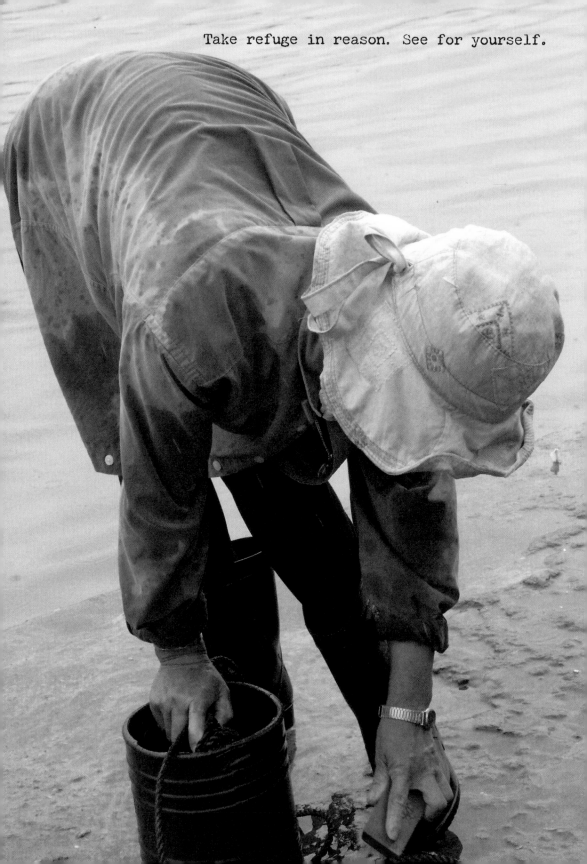

Take refuge in reason. See for yourself.

Named in the seventeenth century after a frilly-edged flower called pink, a member of the genus *Dianthus*, this rosy colour that reminds us of dawn and sunset is just a hint of red. Made up of red and white, pink softens all it touches, so it's small wonder that a pink carnation means 'I will never forget you'.

The quality of energy in pink is determined by how much red is present. White is the potential for fullness, while red aids with the achievement of fulfilling a potential. Pink combines both these energies. Shades of deep pink, such as magenta, are effective in neutralising disorder and violence; some prisons use pink tones to defuse aggressive behaviour. Just like red, bright pinks stimulate energy and can increase your blood pressure, respiration, heartbeat and pulse rate. Pink also encourages action and confidence.

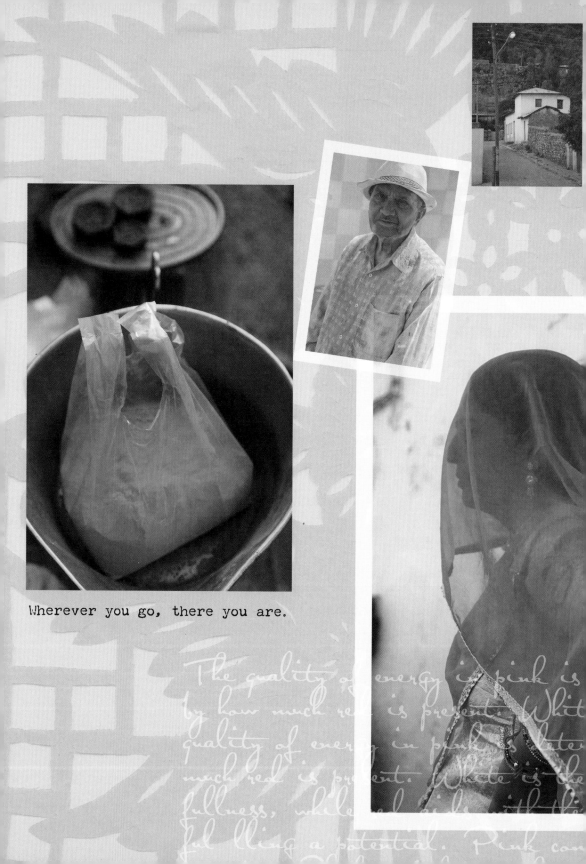

Wherever you go, there you are.

There are friends for reasons,
and some for seasons,
a few forever.

Pinking shears may be used to protect or decorate an edge but have little to do with this blush of colour. Wisely the London *Financial Times* adopted salmon pink in 1893 to give the paper a competitive edge. You too could be tickled pink by the success that will follow if you add a little pink to your life.

Pink is not just for baby girls, you know. But do
you know the history behind this myth? In the 1920s
Western culture began associating colours with
genders; until the 1940s pink was for boys because
it related to red, and was seen as the more masculine
and decisive colour. Blue, for girls, was seen as the
more delicate and dainty colour because it related to
the Virgin Mary. From the 1940s this was inverted.
Thankfully now there is no right or wrong colour
for either sex.

Pink is a quiet colour. In Catholicism
it signifies happiness and joy, while
lovers of beauty embrace pink because it
encourages feelings of caring, tenderness,
self-worth, love and acceptance. When
a touch of pink is added to a home, it
makes it home sweet home instantly.

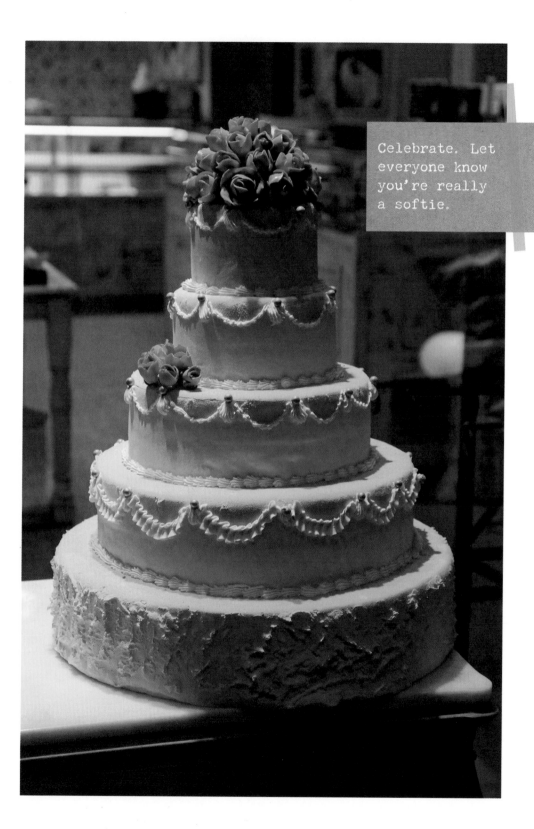

Celebrate. Let
everyone know
you're really
a softie.

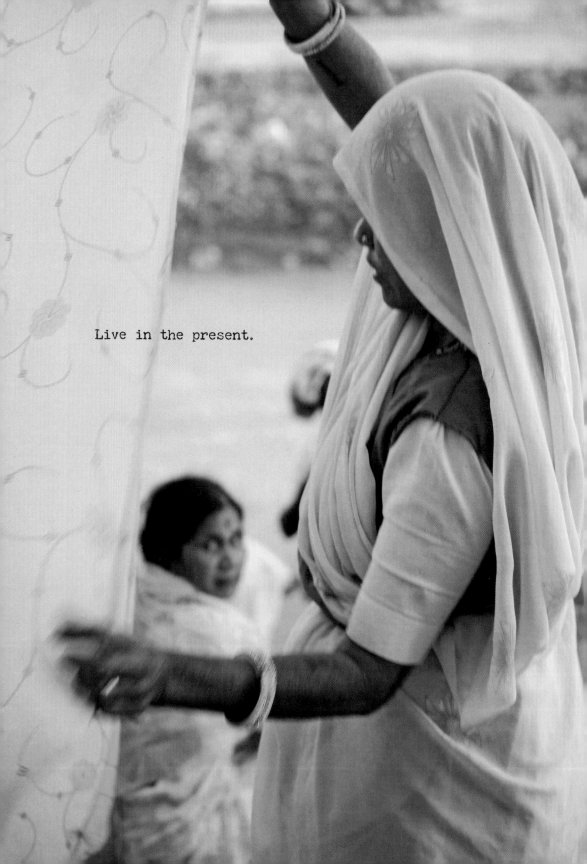

Live in the present.

धर्मेन्द्र फोटो स्टूडीओ

Look for the signs. Know when to quit.

The phrase 'in the pink' originated from the English fox-hunting tradition, where a rider was not granted the right to wear an easily identifiable scarlet-coloured jacket, called a 'pink', until he had demonstrated superior horsemanship and service to the hunt. The phrase evolved to broadly mean the very pinnacle of something during the eighteenth century. It wasn't until the early twentieth century that it was used to describe the rosy glow of a healthy complexion.

The smallest finger on the human hand may be known in English as the pinkie but in Japan pink has a masculine association. Hanami, the viewing of the blooming of pink and white blossom on Sakura cherry trees (*Prunus serrulata*) in spring, is said to represent the Samurai, young Japanese warriors who fell in battle; like the blossoms, they had a short life.

Value your uniqueness.

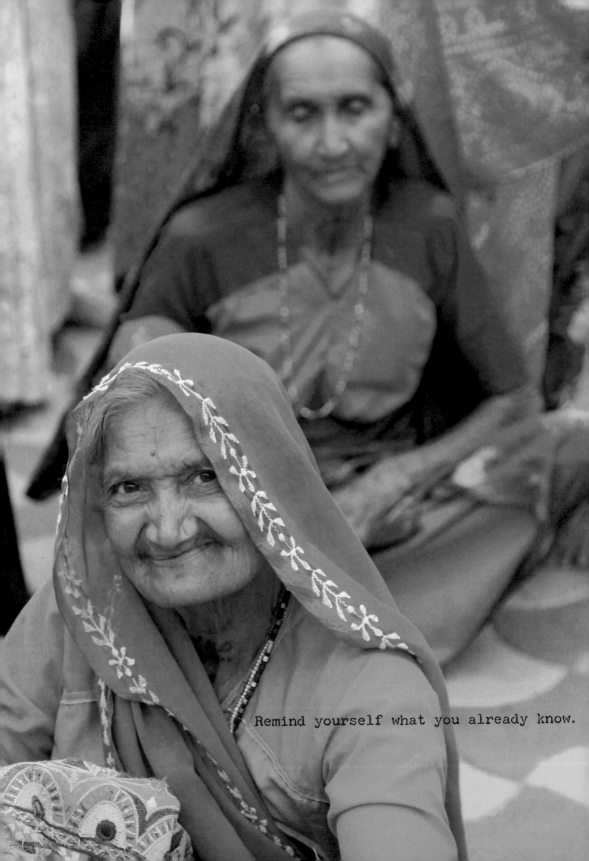

Remind yourself what you already know.

Enjoy your own company.

Jaipur, the pink city, in Rajasthan, India, has become an important destination on the tourist trail because of its tantalisingly toned forts and palaces, vivacious temples and bazaars. As pink encourages friendliness and discourages aggression and ill-will, Jaipur's streets have an infectious joyous feel which may be due in part too, as Diana Vreeland put it, to pink being the navy blue of India.

Marrakesh in Morocco is sometimes referred to as the Rose City because of its salmon-pink buildings and the red clay of the surrounding terrain.

The Chinese didn't recognise pink until they had contact with Western culture and, interestingly, the Chinese word for pink translates as 'foreign colour'.

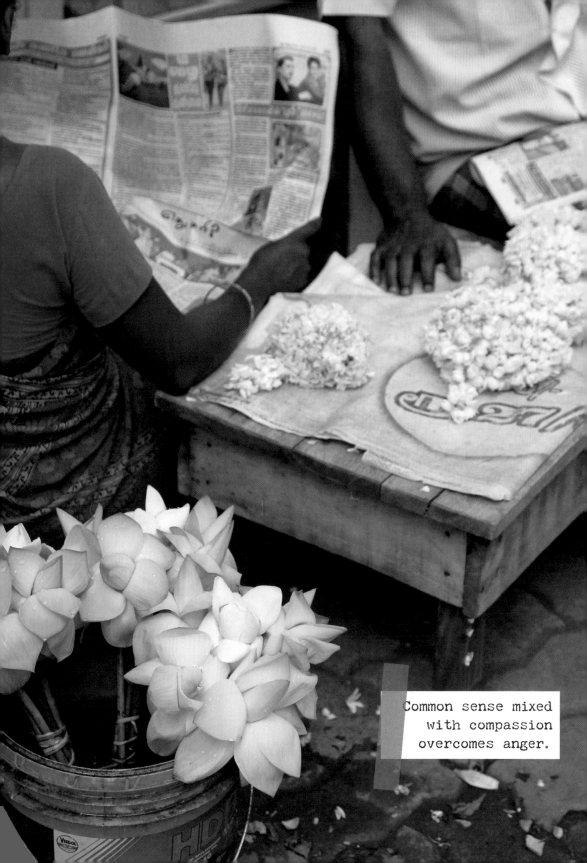

Common sense mixed
with compassion
overcomes anger.

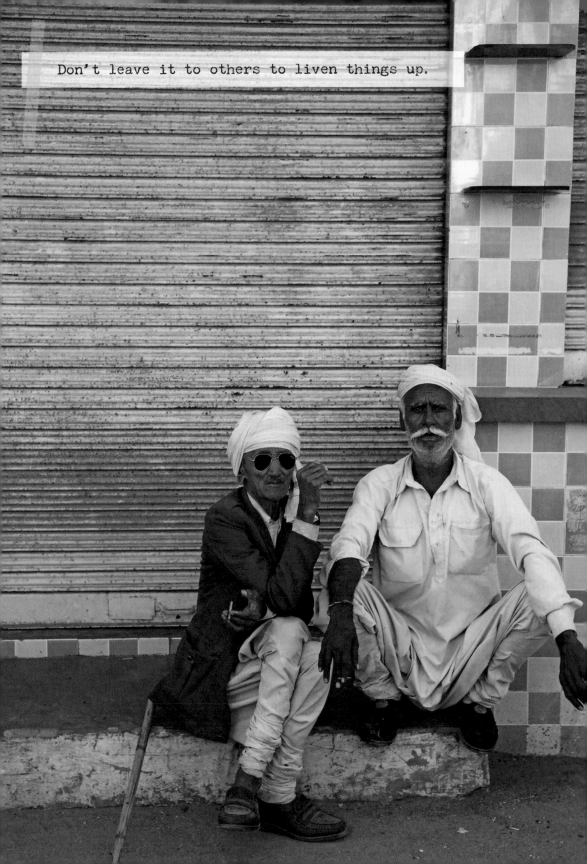

Don't leave it to others to liven things up.

Did you know that pink grapefruit, whose flesh ranges from pale yellow–pink to bright ruby red, is a cross between the sweet orange and a pommelo, and that it has a higher concentration of vitamin A than its yellowish white-fleshed cousin? Its tart citrus scent is great in summer and has the aromatherapy benefits of balancing and refreshing.

Value a sense of humour.

Don't be afraid to connect.

William Morrison and John C. Wharton, candy makers from Nashville, Tennessee, invented fairy floss or, as some call it, cotton candy in 1897. Most flamingos are pink due to pigments in their diet. 'Pink collar' refers to a particular class of jobs once only filled by women. Pink elephants are rarely seen, and pigs may fly, but don't be in any doubt that some humble pink ribbons have done much to raise awareness for breast cancer.

Embrace calming pink. Make the world a softer place, help neutralise disorder and encourage relaxation, acceptance and contentment.

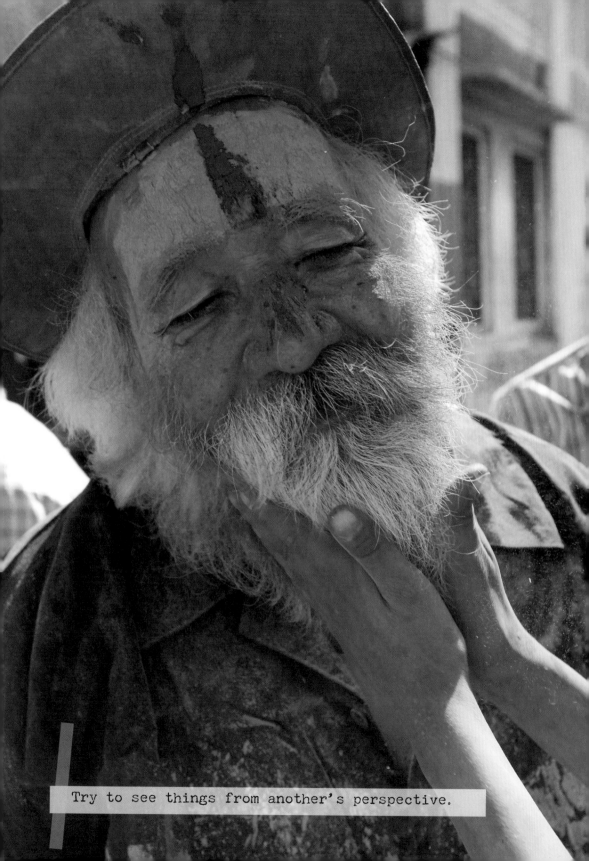

Try to see things from another's perspective.

Tickled Pink X Mix the palest pink and hot red for a warming combination. X Fill a vase with pink hydrangeas. X Place pink salt in a tiny bowl — it will soften your tabletop and flavour your food. X Soften a room with a touch of pink. A cushion. A plate. A pillowslip. X Pink shirts are sexy on men. X Tell a story while wearing pink lipstick. X Be amazed by Pink Floyd's success. X Pink was born Alecia Moore. X Name ten pink things you love. X Give a must-wear-pink party. X Laugh along with the Pink Panther. X Give someone a big bunch of pink David Austin roses. X Rally around a friend who needs you. X Believe in the stork. X Catch a snapper. Then set it free. X Inflate a pink balloon. Hold on tight to it. X Eat at a table laid with pink damask. Do it more than once, especially in Italy if you can. X Moisturise. X Keep your pens in a pink pot to remind yourself to use soft words. X Send a letter in a pink envelope. Make a postie happy. X Snuggle up under a pink

eiderdown. X Visit the ballet. Love those
shoes. X Share some pink coconut ice.
X Pink goes with everything. Use this
information. X It's not just for girls.
X Go to Japan at cherry blossom time. Go
on, just go. X Wear a shocking pink dress
to work. Make them talk. X Gentle blushing
is cute. It's okay to show how you feel.
X Imagine the difference if your school
uniform had been pink. X Place a ring on
your pinkie. X Grow pink carnations just
because they smell so sweet. X Learn about
Roseate Spoonbills. X Be fiercely loyal,
like a flock of wild flamingos who move in
unison when there is a threat. X Watch
flamingos fly. X Study a sunset. Really,
really, really look. X Chill a rosé or
saignée. Drink it outside. With friends.
X Learn the names of at least a dozen pink
roses. X Hug someone. Make them feel warm
all over. X Share the fact you know *roseus*
is the Latin word for rosy or pink. X You
can never have too many peonies. Admire
the clever people who grow them.

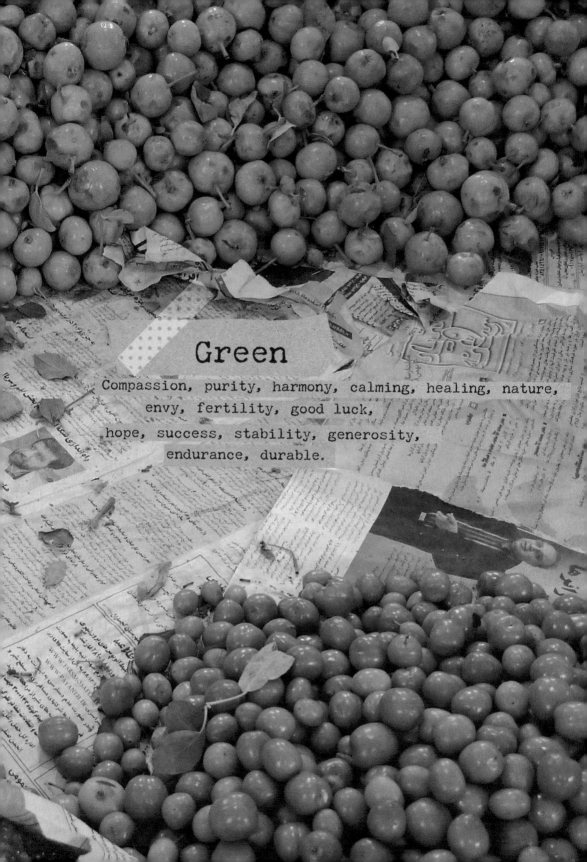

Green

Compassion, purity, harmony, calming, healing, nature, envy, fertility, good luck, hope, success, stability, generosity, endurance, durable.

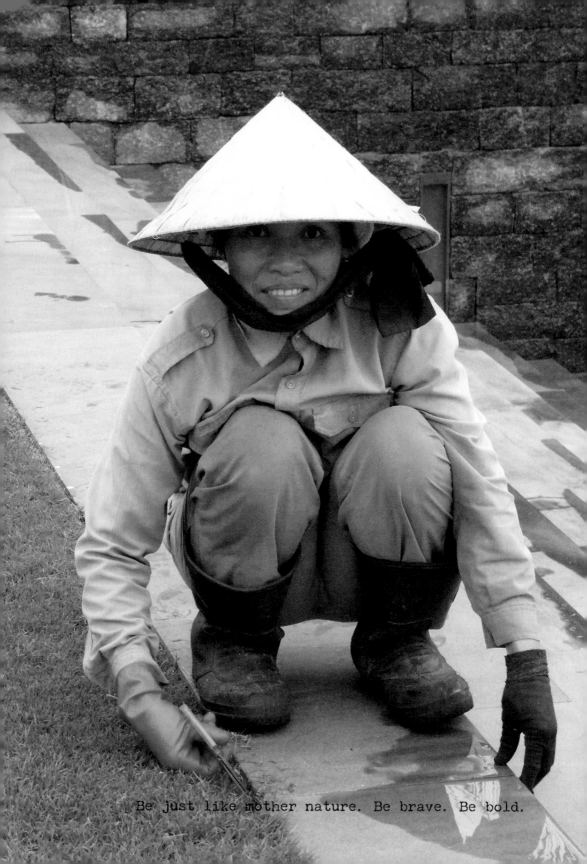

Be just like mother nature. Be brave. Be bold.

Green plants are such an everyday thing it's easy to take them for granted, yet they have a profound effect on our lives. We use them for dyeing and construction, turn them into medicines and things to beautify ourselves and our homes, give them to say we love someone or we are sorry. We're dependent on them for our sustenance, so it seems fitting that in Japan green is regarded as the colour of eternal life.

In China green jade stones represent virtue and beauty. The green belt in Judo symbolises green trees. Just as a green tree is the tallest living thing, so should our own pursuit of knowledge aim high while we keep the goal of our achievement, the top of the tree so to speak, in mind.

In China and France green has negative significance for packaged goods. For some tropical countries it is the colour of danger and for others the colour of Islam.

Green is the largest colour family discernible to the human eye, and included in it is a certain green. You'll find it in India, on walls in the Caribbean, Cuba, Vietnam and Ethiopia, to name but a few places, and on faded and peeling shutters in Europe, inside some varieties of lettuce and in cactus leaves. The sea turns this certain green at times.

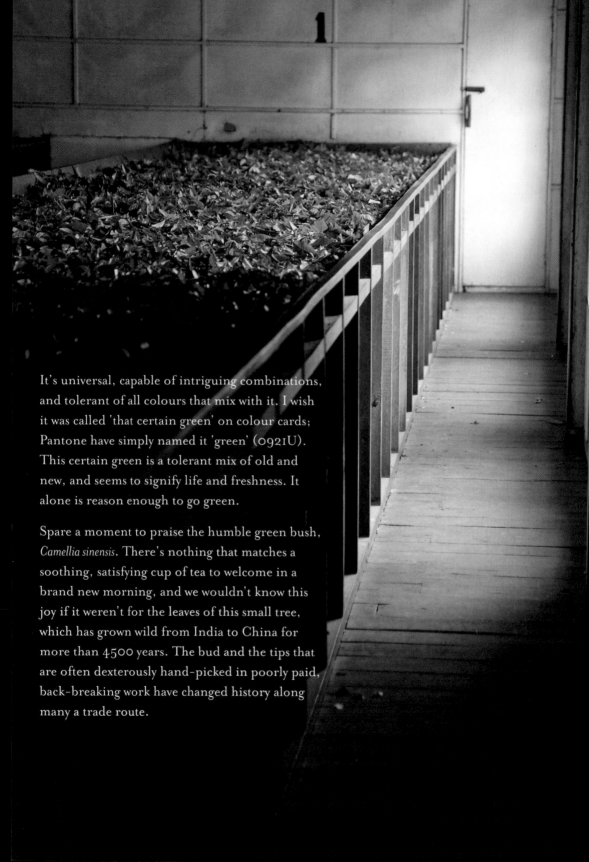

It's universal, capable of intriguing combinations, and tolerant of all colours that mix with it. I wish it was called 'that certain green' on colour cards; Pantone have simply named it 'green' (0921U). This certain green is a tolerant mix of old and new, and seems to signify life and freshness. It alone is reason enough to go green.

Spare a moment to praise the humble green bush, *Camellia sinensis*. There's nothing that matches a soothing, satisfying cup of tea to welcome in a brand new morning, and we wouldn't know this joy if it weren't for the leaves of this small tree, which has grown wild from India to China for more than 4500 years. The bud and the tips that are often dexterously hand-picked in poorly paid, back-breaking work have changed history along many a trade route.

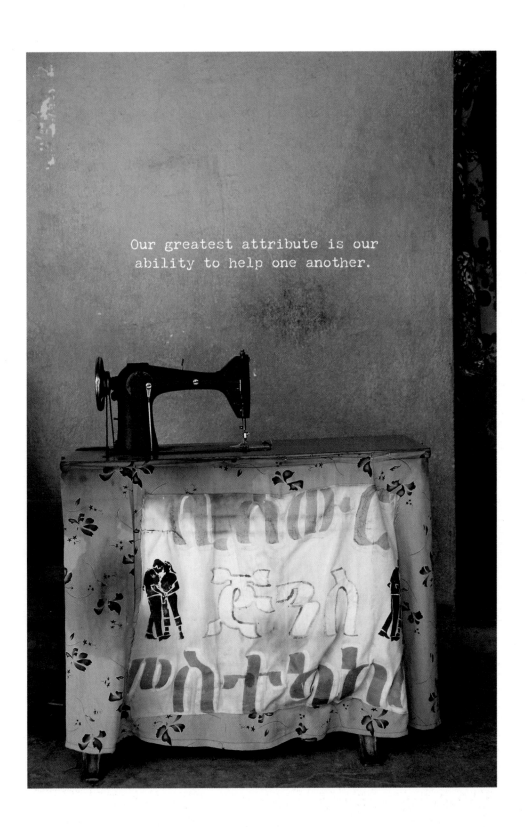

The next time you take a calming tea break, remember those little leaves' humble beginnings and ask yourself how you can green your life in other ways. Try creating your own storm in a teacup and make your friends green with envy by growing lush fragrant herbs and vegetables.

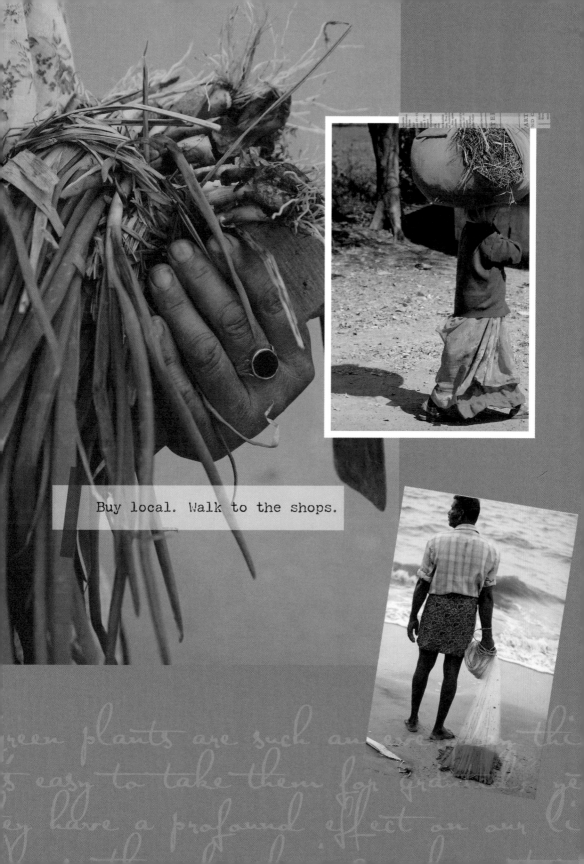

Buy local. Walk to the shops.

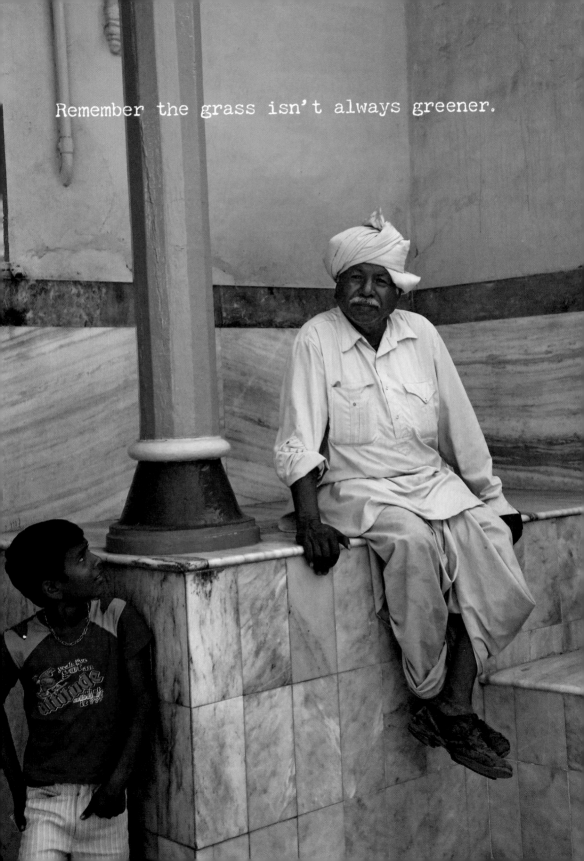

Remember the grass isn't always greener.

Grow a vine. Say 'no' to toxic paints.

Although green is not a primary colour, it is of primary use. Perhaps green has contradictory meanings because it's a mixture of yellow and blue, and the opposite of red. Used to describe someone who is inexperienced, jealous or sick, green is associated with envy and the devil, but also symbolises hope and growth. Islam venerates the colour, as Muslims expect paradise to be full of lush greenery.

But no matter what your beliefs or where you live, green unites us with its tie to nature and fertility. Green is nurturing and natural. It affects us physically, it soothes, relaxes us mentally, helps in alleviating depression, nervousness and anxiety, and offers a sense of renewal, self-control and harmony.

As the word 'green' is closely related to the old English verb *growan*, meaning 'to grow', it's small wonder environmentally-friendly products have adopted it and political groups use it as a symbol of environmental protection and social justice.

Start your own green movement by making all your decisions environmentally-aware ones. Turn out the lights. Up to ten per cent of household power is used by appliances that are left plugged in when they are not in use. Sweep. Encourage others to love the sound of a broom.

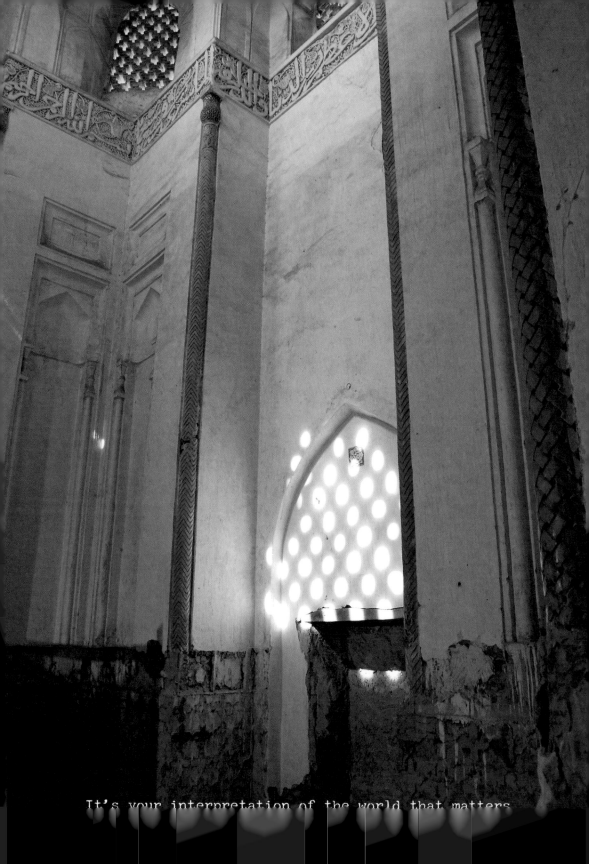

It's your interpretation of the world that matters

Keep the air clean by using a push mower. Grass isn't the only thing you'll be cutting. You'll also be cutting air and noise pollution. Using a petrol-powered lawn mower for one hour produces the same amount of smog-forming hydrocarbons as driving an average car about 300 kilometres (186 miles) under typical driving conditions.

In Portugal, green is the colour of hope because of its associations with spring.

As the emblematic colour of Ireland, it represents the vast green hillsides, as well as Ireland's patron saint, St Patrick, while in the highlands of Scotland people used to wear green as a mark of honour.

Be responsive rather than reactive.

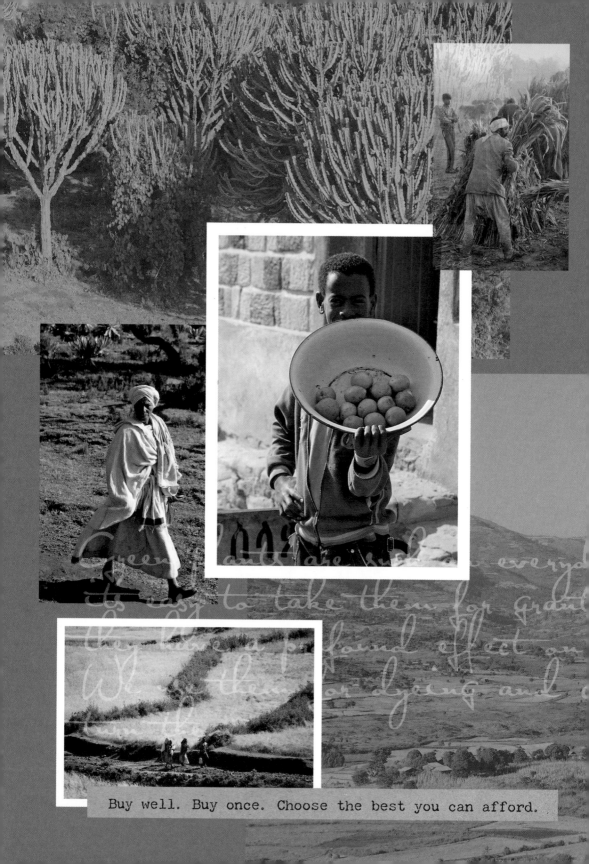

Buy well. Buy once. Choose the best you can afford.

In Aztec culture, green was considered royal because it was the colour of the quetzal plumes used by the Aztec chieftains. Although they may have green in common, the plumes are a far cry from Tom Jones singing about touching the 'Green Green Grass of Home'.

Green may be the colour used for night-vision goggles because the human eye is most sensitive to green and able to discern more shades of it than any other colour, but oddly enough the solid green of Libya's former flag was the only national flag of a single colour.

There's a superstition that sewing with green thread on the eve of a fashion show brings bad luck to the design house.

Leading up to the First World War, the Germans produced much of the dye in Europe. As part of international commerce was blocked at this time, the United States experienced a shortage of colourants and the printing of 'greenback' bank notes was temporarily halted due to the lack of green ink.

Look to the land for inspiration.

No ordinary doctor, Pierre Ordinaire commercialised modern absinthe as a cure-all from 1792. Then, seeing its potential as an aperitif, Henri-Louis Pernod founded the Maison Pernod Fils absinthe company in 1805. Absinthe's moment came with the Algerian wars in the 1830-40s, when French soldiers drank it as a prophylactic against disease. They brought it home, and by the 1860s, Parisian cafés had established 5 pm as *l'heure verte* — 'the green hour'.

Spread the good news. Go green.

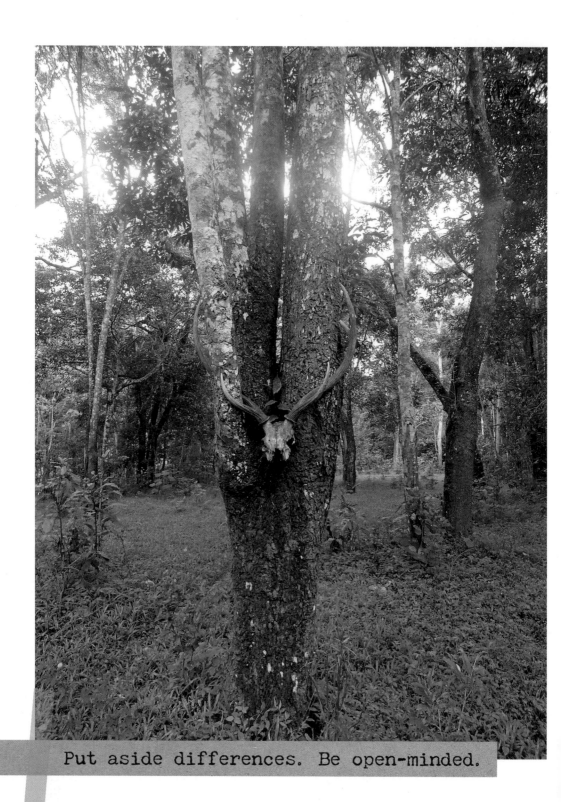

Put aside differences. Be open-minded.

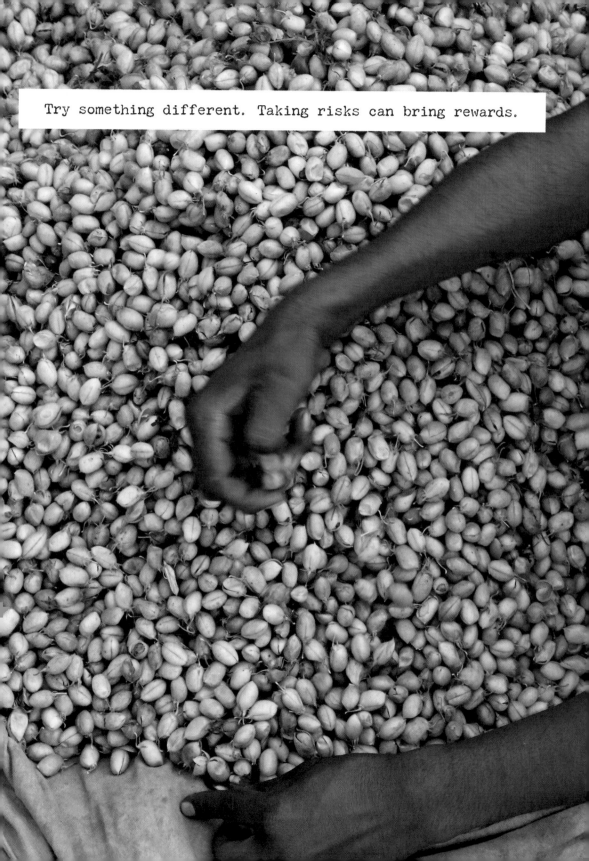
Try something different. Taking risks can bring rewards.

Green Light X Offer a branch of
friendship. X Be amazed at the hope new
growth brings. X Go ahead, take that risk.
X Shell some peas. X Admire a lizard's
camouflage. X Explore a mountain. X Stroll
slowly through a park. Look up. X Go to sea
in a beautiful pea-green boat. Take an owl
and a pussycat with you. X Visit Ireland and
observe St Patrick's Day. X Marinate some
olives. X Soften your roof with moss. X Smell
the freshness of some just picked basil.
X Taste peppery rocket straight from your
garden bed. X Sing along with the frogs. X
Dance to Al Green's 'Let's Stay Together'.
X Be the proud owner of a worm farm. X Pound
some pesto. X Give a gift of green tea. X
Drink from a green cup. X Spot a parrot. X
Squeeze a lime. X Learn about chlorophyll
and never take it for granted again. X Be
diligent about the chemicals you choose. X
Plant a tree to mark each new year. X Look
for leprechauns. X Wrap a green scarf around
your neck to show you care. X Make others
green with envy of your positive attitude.

X Take a back road, enjoy the paddocks and
the trees. X Be grateful for green lights. X
Play leapfrog. X Taste the sea. Share some
unwashed oysters in their shells. X Remember
Kermit's 'Being Green' song. X Eat asparagus
with your fingers. Piece by piece. X Find
peace and quiet in a garden. Best of all,
your garden. X Wish on a four-leaf clover.
X Learn from someone with a green thumb.
X Try to cultivate your own reputation as
having a green thumb or, as some would say,
green fingers. X Get the green light for that
project you have been working on. X You don't
need a green room to prepare to perform. X
Crunch on green beans from summer through to
winter. X Have a birthday party in a park.
X Make useful art. X Place a sprig of mint
in a glass and cover it with boiling water
to be instantly reminded of Morocco. X Dream
of Martians. X Respect nature. Replace only
that which is really necessary. And remember
preloved is a nurturing kind of love. X
Try kissing a frog and see if you too
become a princess.

blue

Truth, healing, change, letting go, tranquillity, faith, new beginnings, creative expression, stability, peace, endurance, durable, harmony, wisdom, trust, calm, confidence, protection, security, loyalty.

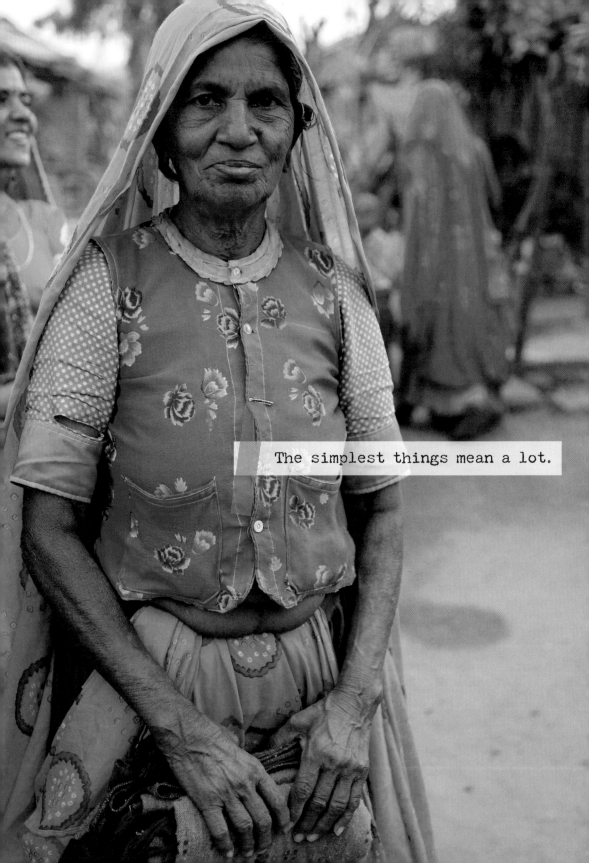

The simplest things mean a lot.

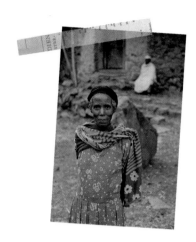

Show you care.

Blue resonates with beauty, purity and wisdom. It's divine because tones of it have specific meanings in the Christian and Islamic religions. It can help ease tension and gives a feeling of tranquillity. Blue also projects an image of power, credibility, trust and professionalism.

An essential colour of nature, blue is the world's most popular colour, perhaps because it is familiar as the colour of the sky on a clear day. With its reminder of the calming effect of the sky and sea in some holistic treatments it is used to help lower respiration and blood pressure.

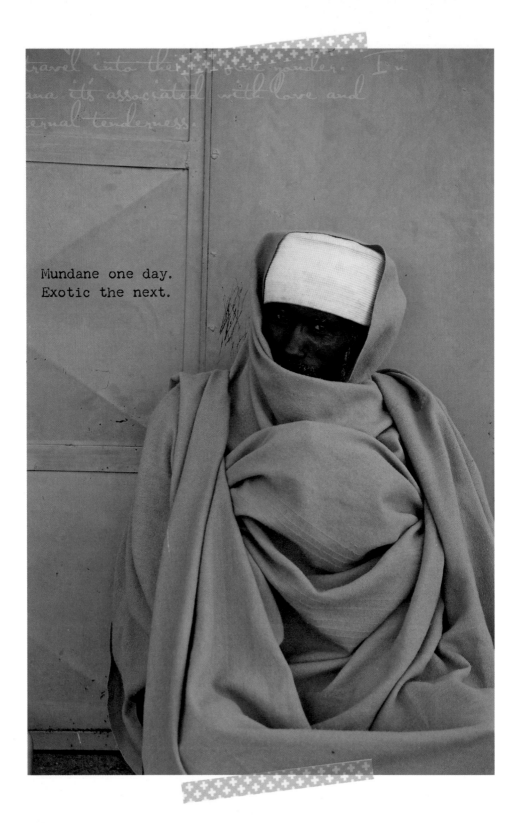

Mundane one day.
Exotic the next.

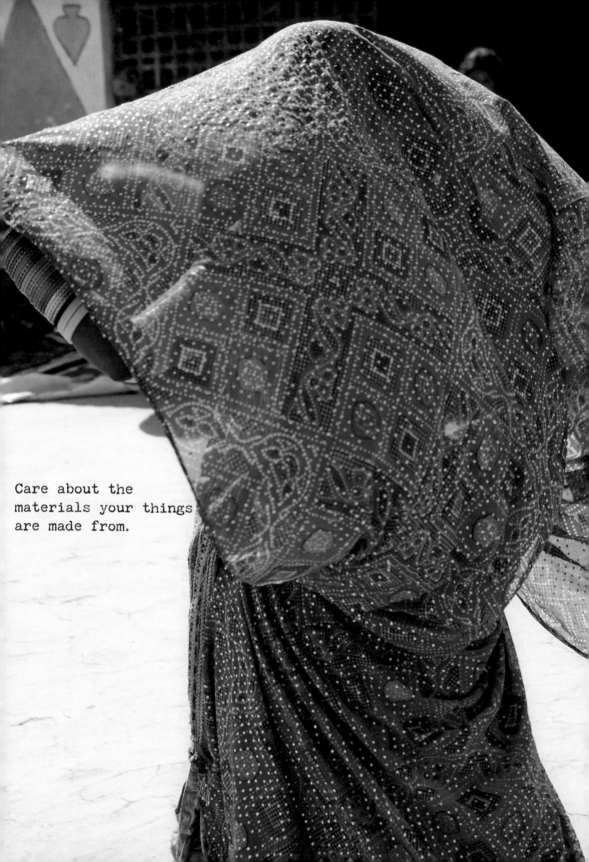

Care about the
materials your things
are made from.

Blue can also be associated with sadness. 'Feeling blue' is derived from a custom among old deepwater sailing ships. When a ship lost its captain or any of its officers during a voyage, it would fly blue flags and return to its home port with a blue band painted along its hull.

Mother nature has an abundant supply of pigments for yellow, red, brown and black. Not so for passive blue. Blue played no part in prehistoric art.

Being rare has made blue prized. You only have to think of all those first-place getters to be assured of its influence. Tattoos too are prized by some. Many suits are carefully accessorised with a blue shirt each day as their owners fight for a place in the game of commercial gains.

The principal blue pigments provided by nature are azurite, lapis lazuli, cobalt and indigo, once upon a time the most important dye in the world. Marco Polo brought lapis lazuli back to Europe from Afghanistan; pigment is still being mined today in the same place. In Roman times Egyptians began using indigo to dye sacred cloth but in the western part of the Roman Empire blue was considered dirty and wearing it was debasing. On women it was a sign of easy virtue and on men an indication of an effeminate or ridiculous trait.

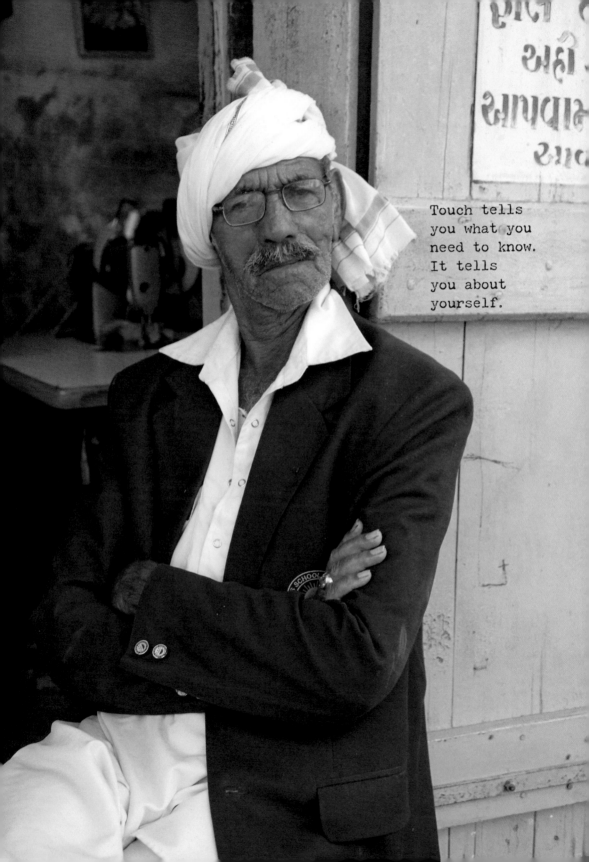

Touch tells
you what you
need to know.
It tells
you about
yourself.

Artistic expression
comes from inner
feelings and cannot
be faked.

Explore fresh ideas.

Some time during antiquity India developed a technique
for tinting with indigo, or *nil* in Hindi. The Venetian
explorer Marco Polo's notes from 1298 tell of a strange
and smelly industry taking place in Kollam, Kerala. It made
social outcasts of the dyers. The brilliant blue dye, indigotin,
was extracted by soaking the leaves of *Indigofera tinctoria* plants
in liquid.

Indigo is a weed. A magic plant whose extract turns yellow
when in water and blue when exposed to air. Today some
Indians ward off mosquitoes by adding indigo to whitewash
when painting the exteriors of their houses, and babies may
have an indigo-dyed cotton cord threaded with painted blue
beads attached to their wrists and ankles to protect them
from the evil eye.

The indigo-dyeing process spread via the East–West trade route as packhorses loaded with bags of indigo travelled the silk roads out of Northern India to the Near East. At first the trade was seen as degrading textiles because they were alienated from their original natural state, but blue showed it was prepared to stand out from the crowd and later became a sign of wealth and truth, and hinted at human mortality.

In Europe some of the dyeing process involved the use of urine. The Greeks called it *indikon* or 'the blue dye from India'. Indigo, popular for more than 4000 years, is still used extensively in West Africa and Asia. The nomadic Tuareg of the Sahara, the 'blue people', wear indigo-dyed robes and turbans as a sign of wealth.

Maintain connections.

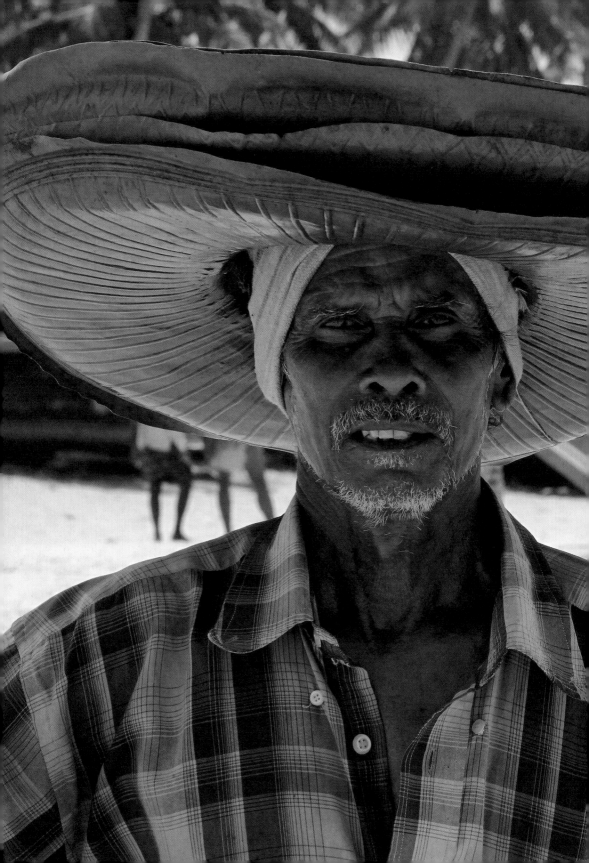

Acknowledge the origins of
things and respect them.

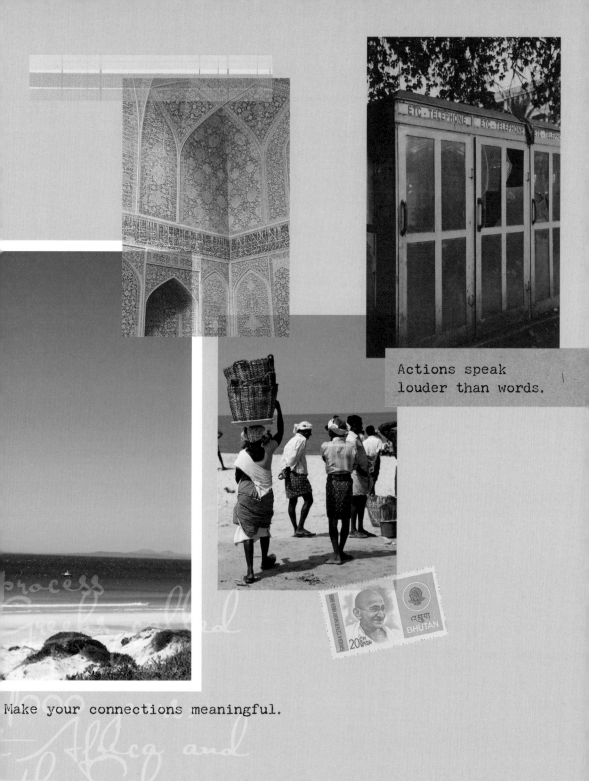

Actions speak
louder than words.

Make your connections meaningful.

Blue is easy to wear and an honest, hard-working colour. It's used with regularity in military and other uniforms, especially when manual labour is involved and tough fabrics are called for. Both war and the Industrial Revolution have been good for the indigo trade. Think bib-and-brace overalls, boiler suits, dungarees and jeans. Blue jeans became the on-board work clothes for the US Navy way back in 1901.

We can thank a German chemist, Adolf von Baeyer, for the synthesis of indigo dye. He discovered it in the 1860s, and won the Nobel Prize for Chemistry in 1905. When industrial substitutes started to be produced in the 1870s, it had a catastrophic effect on the Indian economy. The early 1900s saw a demand for natural indigo fall to an all-time low, and this helped to feed the desire for Indian independence and bring the rule of the British Raj to an end less than fifty years later. In the meantime the German chemical dye industry grew and the profits helped fund Germany's entry into the First World War.

Woad (*Isatis tinctoria*) is indigo's rival dye. The conquering Roman general, Julius Caesar, was known to have covered himself with it, while the Pictish warriors, or painted people, of northern Britain daubed themselves with it to scare their enemies.

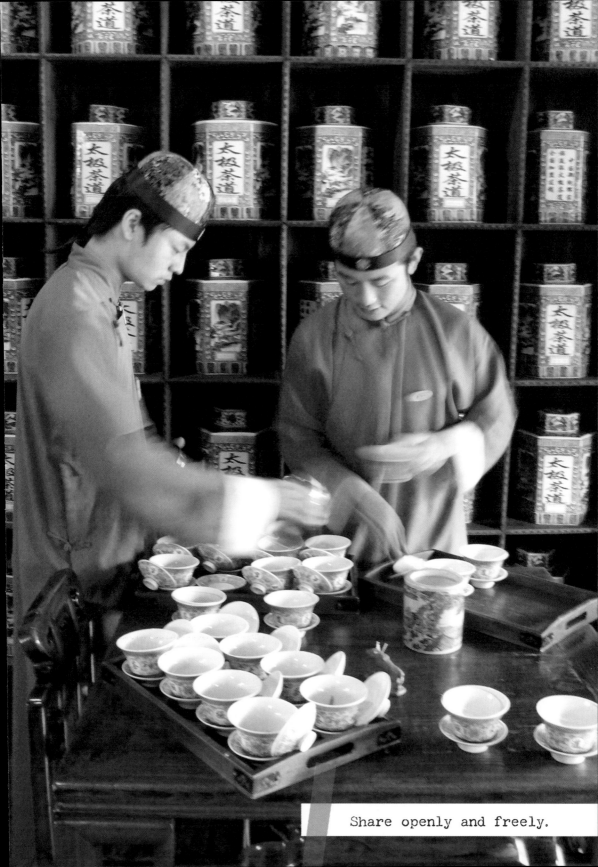

Share openly and freely.

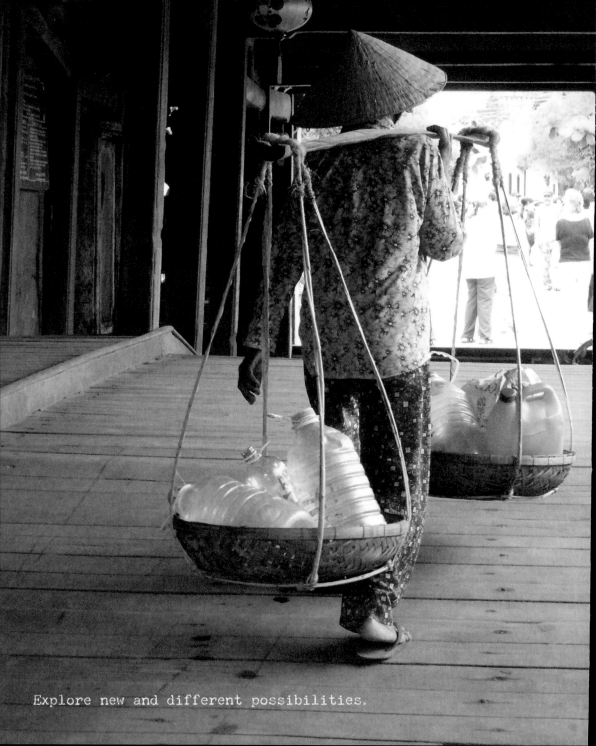

Explore new and different possibilities.

You can if you think you can.

It was the French, especially in the Pays de Cocagne, who
mastered the art of turning woad into dye, while the Germans
produced a chemical Prussian blue made from alum and
animal bones in the early 1700s.

The Chinese used to depend on Persia for blue for their Ming porcelain. In Islamic lands blue is often regarded as a magical colour, bringing either misfortune or happiness, and the devil is repelled with turquoise. The Chinese were superstitious about blue, and associated it with torment. For many years in Turkey and Central Asia blue was the colour of mourning.

We can thank Afghan painters for being the first to crush lapis lazuli in about the fifth century CE. The Venetians imported lapis lazuli during the Middle Ages, calling it *ultramarinus* (coming from beyond the sea), and for artists it became the most beautiful and expensive colour in their palette.

Beginning in the twelfth century, a technique for refining the impurities in lapis lazuli and mixing it into a malleable paste by adding plaster, resins, oil and wax led to luminous blue being reserved for depictions of the Virgin Mary. By the end of the Middle Ages, blue was a dominant colour in the West due to the Church's vision of the Virgin, the King's desires and increasingly sophisticated dyeing techniques. Blue evoked nobility, fidelity and peace.

Blue is an important colour for Judaism. It's the colour of Hanukkah, the Festival of Lights, and the Bible tells Jews to include a thread of blue in their prayer shawls. Historically the blue dye came from a mollusc and so represented the colour of the sea, part of God's gift of the Israeli homeland.

The women of the Ndebele tribe of South Africa paint wall murals on the exterior walls of their houses to record their life events. Until the Second World War the colours they used came from plants and minerals, except for the blue, which was a blue laundry agent usually reserved for whitening clothes.

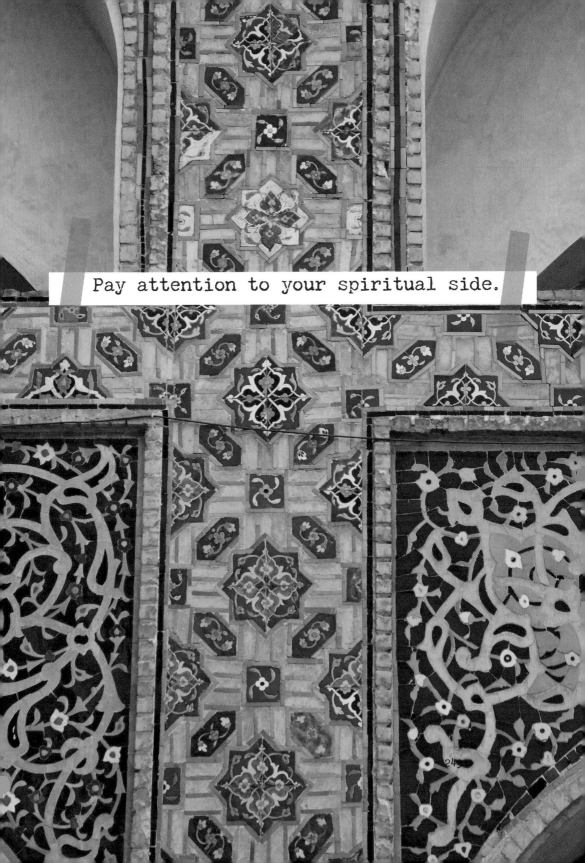

Pay attention to your spiritual side.

Every experience is valuable.

Blue has the magic power of brightening and whitening. Remember those little bags of blue wrapped in muslin and tied with string? Not so long ago, when clothes dried on lines, these mysterious bags were placed with whites in large tubs, heated and stirred around in the final rinse on washday. This was laundry blueing or blue, which disguised any hint of yellowing and helped things look whiter than white. They weighed an ounce (28 grams) and the main ingredients were synthetic ultramarine and baking soda. It was such a cheap, widely available source of ultramarine that it was used in paint, dye and ink across the world. It's been found in early twentieth century clothing made by indigenous people in Quebec, and in the ink used in Coptic manuscripts in 1930s Egypt. Now it's used for providing the blue water for magical Caribbean traditional rituals.

Our infatuation with blue continues, and we now perceive it as a universally neutral colour, bringing the world together in the flag of the European Union, the uniform of the United Nations Forces and the millions of pairs of jeans worn every day.

Avoid negativity.

Our infatuation with
perceive it as a univer
the world together in
the uniform of the Uni
millions of pairs of j

unt No.

et No.

Measure your success by how far you have come.

continues, and we now neutral colour, bringing ag of the European Union, Nations Forces and the worn every day.

Understatement is the best statement.

When you're feeling blue all you have to do X Plant some cornflowers (also called bachelor's buttons) to bloom in summer. X Or pick up some soft blue hydrangeas from the market instead. X Collect blue and white china, especially teacups, to mix and match. X Display mismatched plates and jugs but use them regularly. X Match the spines of your books by colour, giving preference to blue. X Scatter indigo cushions around. Let them tell the story of where they're from. X Read about 'blue bloods', people of noble birth. X Take a dip in the cool deep blue sea. X Look to the sky and appreciate how the blue fades in the distance. X Help someone who is feeling blue to laugh and see the joy in your friendship. X Wrap a classic navy and white spotted scarf around your neck and lap up the compliments. X Take time out and listen to the blues, Gershwin's 'Rhapsody in Blue' or Tom Waits' 'Blue Valentine'. Whichever tickles your fancy. X Marvel at bluetooth technology. X Contemplate mountains that take on a blue hue. X Wonder at Yves Klein's

paintings. X Study Picasso's Blue Period for
inspiration in mixing tones. X Doodle with
a blue pen. Draw a bluebird of happiness. X
Write a letter on old-fashioned blue airmail
paper. X Spare a thought for owls, the only
birds who can see blue. X Don't take blue
jeans for granted. X In Chinese culture blue
is associated with wood, east and spring. X
Throw a Chinese banquet in spring and serve
it from a wooden table facing east. X Show
appreciation for blue's non-gender-specific
appeal. X Jive to Elvis strumming 'Blue Suede
Shoes'. X Marvel how the colour of a blue
butterfly's wings is reflection. X Broaden your
horizons. X Most people don't drink enough
water. Make sure you are not one of them.
X Wear a blue beard to frighten the enemy.
X Don't turn your back on someone who is
feeling blue. Listen, be empathetic. X Help
another dry their tears. Explain the cure
for unhappiness is happiness. X Watch
raindrops enter a river. X Admire a bird
learning to fly. X Take a lesson from
salmon. Swim upstream.

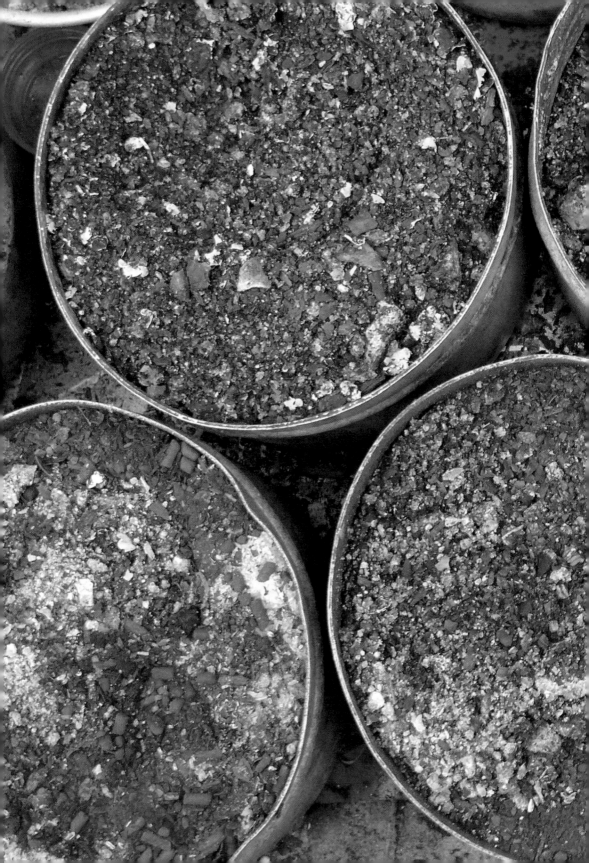

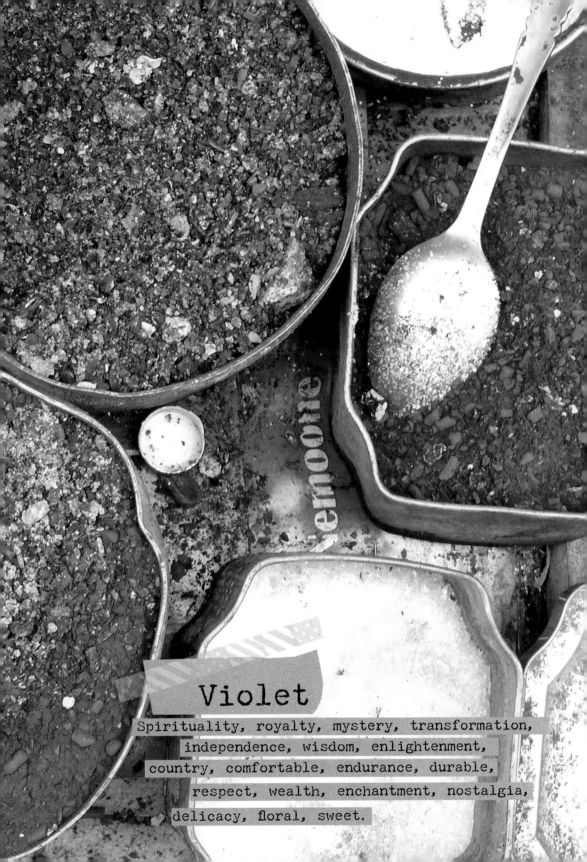

Violet

Spirituality, royalty, mystery, transformation,
independence, wisdom, enlightenment,
country, comfortable, endurance, durable,
respect, wealth, enchantment, nostalgia,
delicacy, floral, sweet.

Poised somewhere between red and blue, and named after a flower, violet is more blue than red, while purple is more red than blue.

In Chinese painting violet's combination of red and blue represents the harmony of the universe. If you look closely enough, deep violet is the colour of many a shadow, and despite market research claiming it is not a popular colour for food packaging, in England they wrap chocolate in it to give it a right royal feel.

See yourself as valuable.

Dream.

1 HAND FAN
2 CARPET

Neolithic people may have used dwarf elderberries and blackberries to dye textiles a lilac hue but the Phoenicians are considered responsible for discovering a permanent purple dye. They used molluscs from the Mediterranean, broke them open, soaked them in basins, then removed the mucus from a minuscule gland. When exposed to sunlight, the mucus turned a whitish colour, then yellowish-green, green, violet and finally a deep red. Exposure to the light was critical and determined the final colour for dyeing.

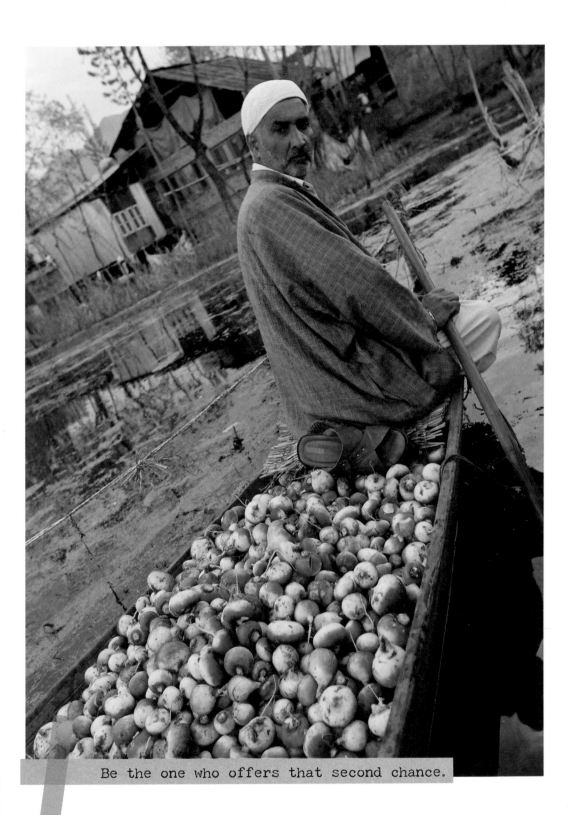
Be the one who offers that second chance.

In Guatemala mollusc whi to dye bark

In Guatemala they also used the mucus from a mollusc while in Polynesia sea urchins were used to dye bark cloth lavender and purple. Mediaeval Europe saw the introduction of the use of madder plants, mordant and kermes insects for violet dyes.

Violet is one of the most complex dyes to extract, so it is expensive. From the beginning it represented prestige and has since been reserved for magistrates, nobles, priests and kings. Roman emperors made purple exclusively their own, and it became the symbol of political power.

In Imperial China colours had indicated court rankings, which were closely linked to a religious and philosophical system. Violet seems to have been added to their spectrum during the Han dynasty in the early third century CE. It was regarded as transcending the duality of *yin* and *yang* and, in painting, symbolised the ultimate harmony of the universe.

By the ninth century the ancient formulas for purple were lost, and it wasn't until the beginning of the twentieth century that the chemical structure of purple and methods for dyeing with purple were rediscovered.

ጠባዩት

ባልትና

☎ 0347753275
0914754855

Be prepared to
negotiate. Be open
to compromise.

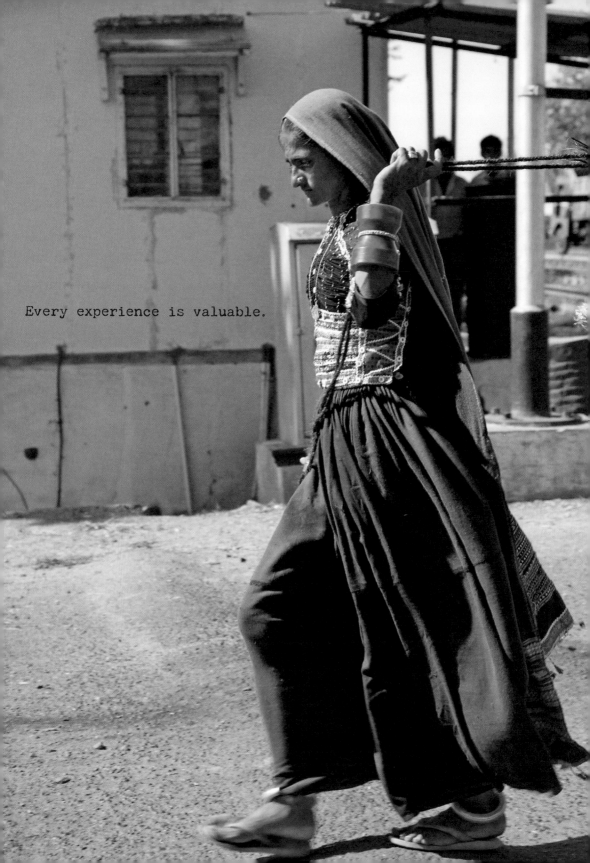

Every experience is valuable.

Research has shown purple vegetables and fruits contain important nutrients that have many health benefits, including slowing ageing and age-related memory loss.

More good purple news is that blueberries, which contain a large number of antioxidants, can help you lose weight by reducing food cravings. They have also been known to reduce cholesterol and help prevent urinary tract infections because of a nutrient called proanthocyanidin, which lines the urinary tract and prevents bacteria from sticking.

Amazingly, purple cabbage contains thirty-six different types of antioxidants, including the health-giving anthocyanins. There is evidence to suggest that it helps to build a healthy brain and heart as well as acting as a fat burner.

Figs have been used as a sweetener since ancient times. Shown in paintings on Greek vases, they too are full of nutrients, including calcium, magnesium and fibre. The Japanese use figs to reduce high blood pressure and high blood sugar.

Travel because you can.

Ultraviolet may be invisible to your eyes, and cause sunburn, but this ultra-special violet has many beneficial attributes, not the least of which is your daily dose of vitamin D, which in turn helps with the regulatory roles in your calcium metabolism (vital for normal functioning of the nervous system, bone growth and maintenance of bone density), immunity, cell proliferation, insulin secretion and blood pressure. So even without you being able to see it, violet is doing you a good turn every day you go out in the sunshine.

Don't dwell on the past, or what is yet to be.

It's important to have a sense of involvement.

No shrinking violet X Did you know there are more than 400 species of violets? Some annual. Some perennial. Never look at them in the same way again. X Crush a violet chocolate and honeycomb bar. Sprinkle it over pure vanilla ice cream. X Surprise someone with your knowledge that purple heart is the name of both a species of flowering plant (*Peltogyne species*) native to the rainforests of Central and South America and a medal of honour introduced by George Washington in 1782. X Appreciate perfume that smells of violets. X Get your daily dose of antioxidants. Embrace eggplant, purple carrots, purple cabbage, beets, blueberries, blackberries, plums, elderberries, figs, raisins, pomegranates and goji berries. They'll help defend your body against stress and promote healing. X Use lavender oil for its calming effects. X Peel a purple onion and marvel at its layered interior. X Acknowledge a significant February or Piscean birthday with an amethyst. It's

really quartz by another name. X Sing along
to the 'one-eyed one-horned flying Purple
People Eater'. If he can get a job in rock
'n' roll, so can you. X Watch the movie *The
Color Purple*. Or read the book by Alice
Walker. Both haunting. X Violet has the final
place in a rainbow. Wish upon one. X Make
your violet pale. Wear mauve. X Worship the
smell of lilacs. X Leonardo da Vinci believed
the power of meditation increases ten times
when it is performed in a purple light. In
his case, from a stained glass window. Try
out his theory. X Touch a Tibetan amethyst,
considered to be sacred to Buddha. Rosaries
are often made from it. X In Japan purple
signifies wealth and position. Learn more. X
Practise *pysanky*, the traditional Ukrainian
form of egg dyeing, where purple speaks of
fasting, faith, patience and trust. X Romance
under some wisteria. X Partner vivid violet
and bright red. They're great together. X
Greedy people gather the bunch of grapes.
Generous people taste all the grapes in one.

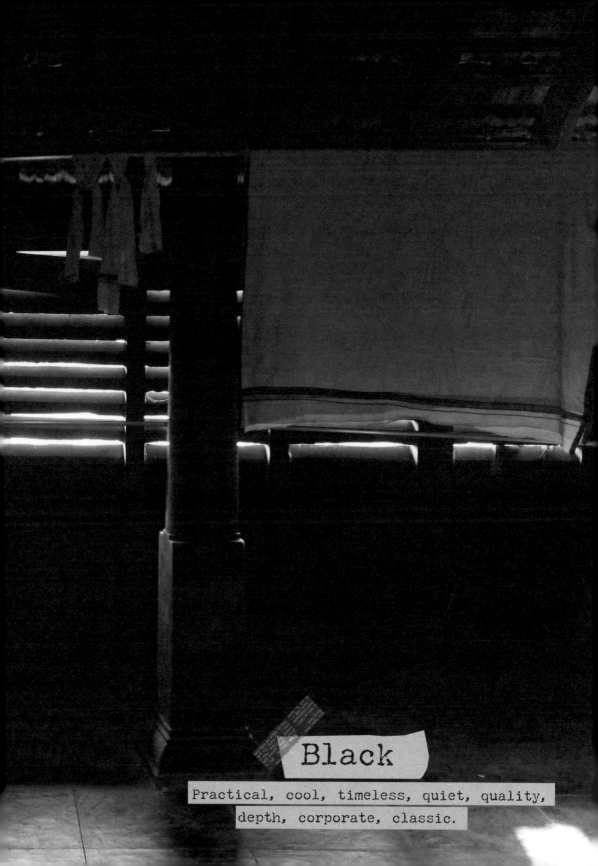

Black

Practical, cool, timeless, quiet, quality, depth, corporate, classic.

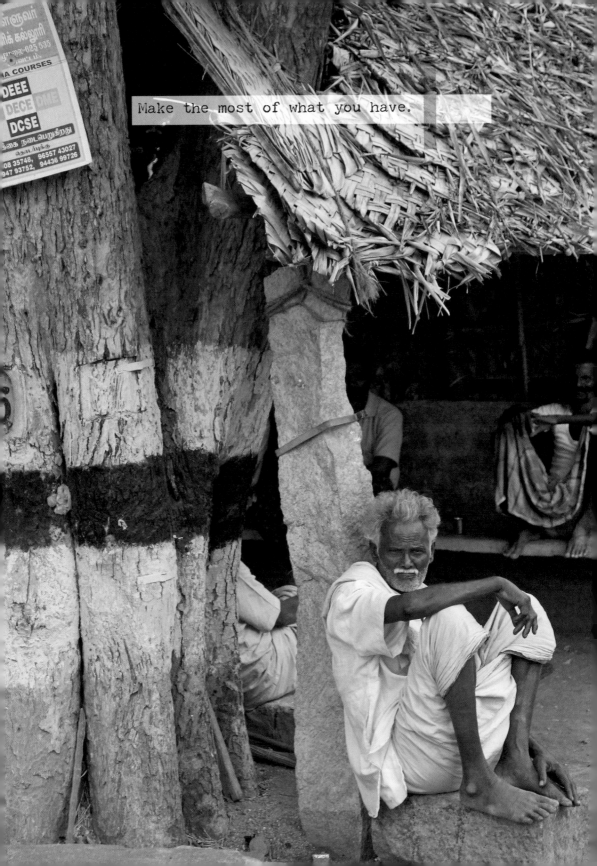

Make the most of what you have.

Think Gothic. Think black. Black is perverse and ambivalent. It has intensity. It's strong, the colour of many words, and we all know there's good black and evil black. It has a greater depth than any other colour.

In subtractive colour theory, which deals with surface colour and pigments, black is the combination of all colours, whereas in additive colour theory, based on coloured light, black is the absence of colour.

Like white, black is a colour that does not exist in pure form except in our imaginations. No colouring agent yields a perfect black; blacks are either bluish or reddish—cool or warm. Black absorbs light, and no paint or dye can quite achieve perfect absorption. It took centuries to create fine blacks in dyeing but good carbon black pigments that absorb light well and approximate a true black have been around since antiquity. Traditionally natural blacks are made by mixing a very dark red–brown with a dark blue.

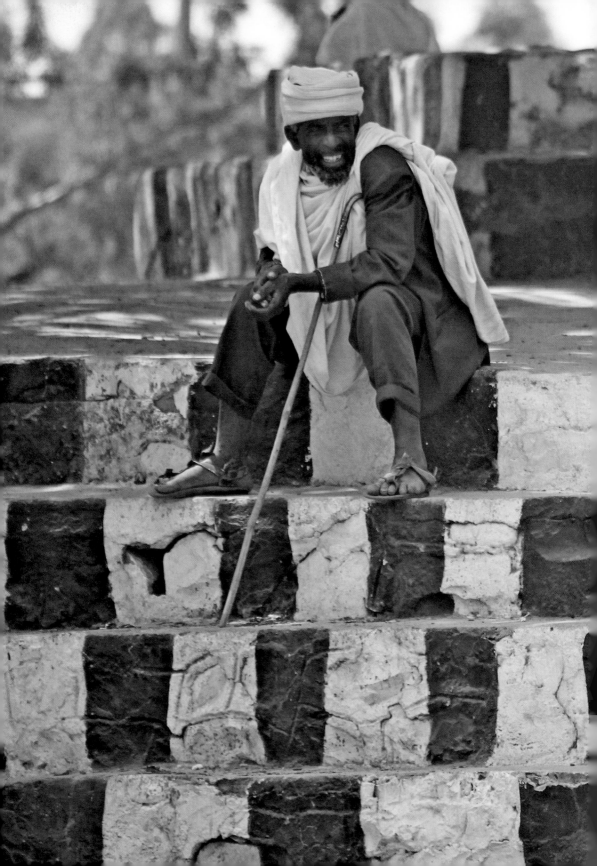

Be discerning. Let go of what you are not.

There's something magical about a blackbird singing in the dead of night.

In Northwest Africa, women put on a black dress after seven days of marriage to tell the world of their changed status.

Explore both internal and external means of happiness.

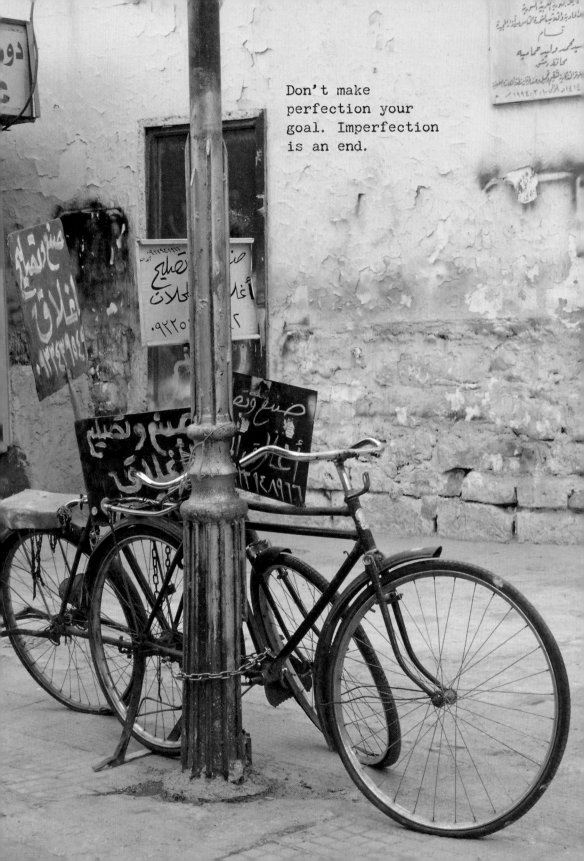

Don't make perfection your goal. Imperfection is an end.

In ancient Egypt, black pigments were created from carbon compounds such as soot, ground charcoal or burnt animal bones, and black (*kem*) was a symbol of both the night and death. Osiris, their king of the afterlife, was called the Black One, and Anubis, the god of embalming, was depicted as a black jackal or dog, despite real jackals and dogs typically being brown.

Symbolising death meant black was also a natural symbol of the underworld and of resurrection. As a complete contradiction, black was also used symbolically to depict fertility and life. This is thought to be due to the abundance provided by the black silt, *tam'ye*, with the annual flooding of the Nile. The colour of the silt became emblematic of Egypt itself, with its people calling the country Kemet, the Black Land, in early antiquity.

The womb of all beings is black; conversely it's also the colour of mourning in Christianity. Its use probably came from the ancient Semitic custom of blackening faces with ashes or dirt as a mark of grief and submission and also to make the mourners unrecognisable to the malignant dead. In ancient Greece, dressing in black to signify mourning originated as a representation of non-life.

For the Chinese black is *yin*, a female colour, making it earthy, instinctive and maternal. It is indeed the colour of the earth, which harbours and controls the growth of the seeds that supply us with essential sustenance.

In the religious cosmology of Bali, colours are attributed to the gods. The Balinese use black and white check ceremonial textiles to illustrate the equilibrium of the world and perfect harmony; the Hindu goddesses, Durga and Kali, symbolise the duality of life and death.

Black can suggest tense and perverse situations, the dark of night when all other colours and movement are swallowed up. Yet, far from being nothingness, darkness is full of life.

The French painter Henri Matisse happily explained that he used black as a colour of light, not darkness. Clever fishermen agree by tying black flags to their traps so they can see them in the midst of the glimmering sea.

Our prehistoric ancestors discovered charcoal at the same time as fire; with charcoal's ability to be altered and corrected, many a fine line has been made with it ever since. Black is in the palette of all artists, whatever their era or culture. Black is also taken for granted as the everyday colour of preference, for it's more often than not the colour of the ink that carries our words and shares our messages.

You don't have to react to your reactions.

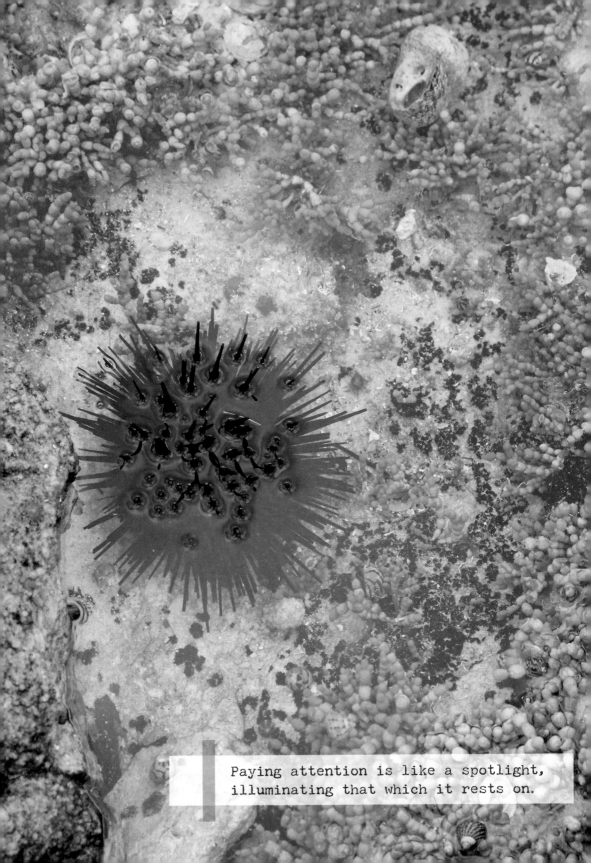

Paying attention is like a spotlight,
illuminating that which it rests on.

Everything is relative.

When nothing goes
right, go left.

In the latter part of the fourteenth century, as dyeing techniques improved, a vogue for black was launched in the West. This continued into the fifteenth and sixteenth centuries, and during the Reformation, sombre dress was praised as a sign of humility and modesty. The regal black of the aristocracy co-existed with the moral black of the religious orders, both Catholic and Protestant, and black became the colour of mourning.

From the nineteenth century onwards, black became the colour for all occasions, but never more so than with the classic little black dress and the black tux, which makes all men look handsome, as the popular and accepted choice for evening.

Be affectionate.

The dark part of our souls is considered black, and in Islam those with a base and vulgar nature are said to have a black heart. With all its lurking dangers, black has been used as a banner of bloody dictatorships and to mark those with hearts of stone.

But if black is menacing, it can also be beautiful, protective and warm.

As black is considered the sum of all colours by some, it seems appropriate that black clouds announce rain and life-giving moisture.

Black so often has the last word, and it seems appropriate that it does so here as the last colour.

See the extraordinary in the ordinary.

Put friendship before cleaning.

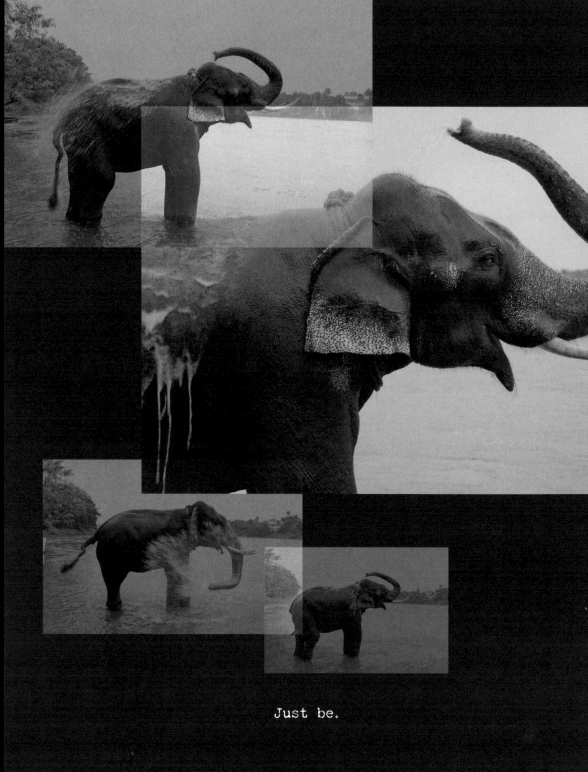

Just be.

Forgive then forget.

Black as the night X Appreciate the versatility of an understated little black dress. Then add some colour. X Be nurtured by a pot of black tea then nurture your garden with the still wet leaves. X Admire the power of the pencil. Take some graphite for a walk across a page. X Type a letter to a long lost friend. Post it. Let them know you care. X Spots wouldn't be the same without black. X Polish your shoes. Make them shine. X Crack a crossword every day. Keep your mind agile. X Bake a blackberry pie. X Turn off your TV. Appreciate silence. X Watch your shadow; it is a passing thing. Surprisingly it may not be black. X Join a book club. Imagine all those marvellous words you can share. X Tell someone you admire their silky black hair. X Spare a moment for those who have been plunged into darkness. X Every room needs weight. Add it with a touch of black. X Admire a packet of liquorice allsorts. X Try squid-ink pasta. X Care for your camera.

Give it a black leather case. X Marvel at
the night sky and all its galaxies. X Be glad
you're not a bat hanging about upside down. X
Learn about *film noir*. X Amuse yourself with
a pirate movie, mate. X Do a first aid course
just in case you need to know how to treat a
black snake bite. X Show respect for spiders.
Especially funnel webs and black widows. X
Collect etchings. X Write with a fountain
pen. X Hug a friend. Be there for them in
their dark moments. X Notice how talk changes
when the lights are out. X Mosquitoes are
attracted to dark colours, so avoid wearing
black when they're buzzing about. X 'Paint It
Black' with the Rolling Stones. X Monochrome
photographs tell endless stories. X Be amazed
by anyone who enjoys black pudding. X Be
thankful you are not stuck in traffic on Black
Friday. X Glossy front doors reflect elegance.
X Draw something. Anything. Every day. X
Discover the Black Hmong for yourself. X
Nurture your ability to be uncertain.

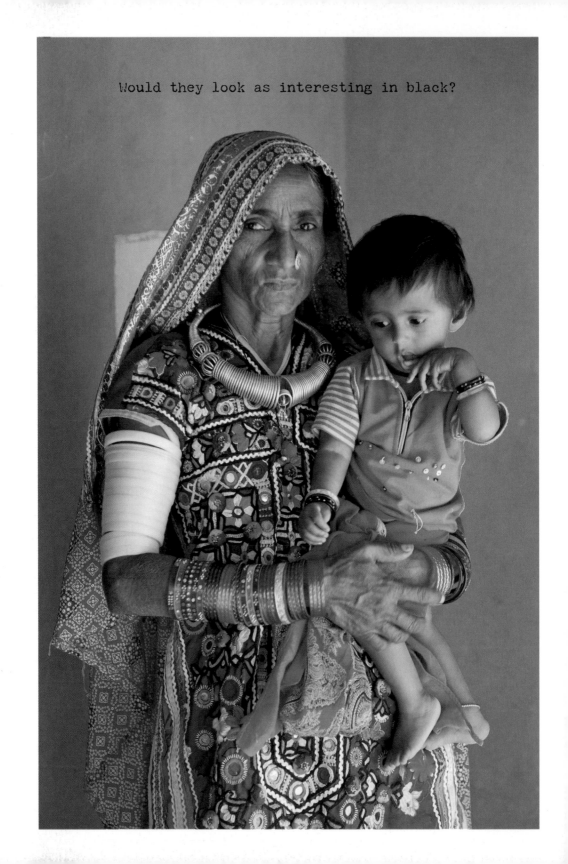
Would they look as interesting in black?

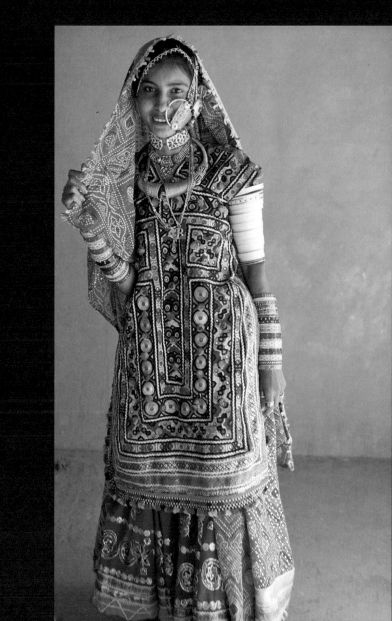

Definitions

Hue *is just another name for a colour.*

The primary colours *are red, yellow and blue. They cannot be mixed from any other colours.*

Secondary colours *are two primaries mixed together, resulting in orange, green and violet.*

Tertiary colours *are what happens when one primary and one secondary colour are mixed together.*

Warm colours *are reds, oranges and yellows.*

Cool colours *are greens, blues and violets.*

Tint *is a colour + white.*

Tone *is a colour + grey.*

Shade *is a colour + black.*

A **key colour** *is the dominant colour in a colour scheme or mixture.*

Neutral colours *are black, white, grey and sometimes tones of the brown family. Black and white are thought of as neutrals because they do not change colour. Neutral grey is a combination of black and white. Neutrals contain equal parts of each of the three primary colours. When neutrals are added to another colour, only the value changes.*

Colour change *If you try to make a colour darker by adding a darker colour to it, the colour (hue) changes.*

Intensity or chroma *is the brightness or dullness of a colour.*

Value *is the lightness or darkness of a colour. It's also the relationship of light to dark. You can change the value of a colour by adding black (shade) or white (tint) or grey (tone). As white is added to a colour, it becomes higher in value (lighter).*

A GOOD RULE "Do Unto Others As Yo

As black is added, it becomes lower in value (darker). Values that are close together have a calm effect. You can use values of pure hues as well as those of tints and shades to create movement. Value contrasts highlight texture and are an effective means of directing a viewer's attention.

Complementary colour means combining a shade, tint or tone of one colour and the opposite colour on the colour wheel. For example, blue and orange, or red and green.

Split complementary schemes use a colour with the two colours adjacent to its complementary colour, which makes for high contrast without the strong tension of a straight complementary combination.

Triadic schemes use three colours equally spaced around the colour wheel and offer strong visual contrast while retaining harmony and richness. They look and feel balanced and harmonious.

Tetradic or double complementary schemes are the most varied because they use two complementary colour pairs. It can be hard to harmonise using these combinations.

Monochromatic simply means using any shade, tint or tone of one colour for a unifying and harmonious effect.

Analogous means using shades, tints or tones of colours that lie adjacent to each other on the colour wheel.

Achromatic is a colourless scheme using blacks, whites and greys.

Light can subdue or enhance a colour. For instance, evening and candlelight create a distortion so light colours need more intensity and dark colours less.

Distance causes receding (cool) colours to black out, so lighter colour values should be used for greater emphasis.

7 8 9 10 11 12

Vould Have Them Do Unto You"

Palettes

Colour affects our well being. In our homes it can have a mysterious influence, in our clothes it's at its best when well suited to our colouring. The colours you choose are part of your personality. Our response to colour is intensely personal and is based on aesthetic and emotional grounds. You are the colour you choose. Wherever, and whenever, you were born memories of your childhood include subliminal colour associations. These stay with you, a constant presence, a connection. More often than not early favourites remain favourites due to a memory associated with them.

No colour actually means anything stripped of its context and history. Colour is a coded system, one that varies with different societies, so be nomadically curious and inspired by the spontaneity of other cultures. Colour links us with its unspoken language. Allow colour to bring beauty and individuality into your life. Use your intuition, it's the highest form of reason, and you will naturally gravitate to your palette.

Decide on a palette that feels right to you and don't waver from it. Look at the colours you are comfortable with — your clothes and all the things you've chosen around you. That's you. Work

within this palette but vary your combinations. Colour is not constant. It takes on different characteristics in response to what it is next to, the shapes, objects and space it sits within.

Allow yourself to blossom. Be inventive, add an element of surprise, an unexpected juxtaposition. Respond to the environment and the seasons. Harmonise. Learn from history, the work and wisdom of Matisse, Bonnard and Vuillard. Make statements. Blue and white for a calm Mediterranean bedroom, buttercup yellow in the bathroom to wake you up, poppy red in the kitchen for luxurious stimulation. Generally cool colours make a room feel larger, while warm colours make them smaller. The stronger the tone the greater the impact. Light colours expand the available light and space, by contrasting them with darker colours the walls will look even lighter. If you want your home to flow from room to room use colours with the same weight. Just as shades of colour are the strength in a painting so they are in your way of being. They soften or accelerate reactions. Look for a balance in the depth of the colours you combine, work with texture, pattern, shape, and light. Trust your eye, you'll know when everything clicks.

About the author

Ever since Victoria Alexander was small all she has wanted to do was play with colour. Once upon a time she was a fashion editor for *Vogue* and *Cosmopolitan*. These days she loves writing and picture hunting with her camera. She has been a freelance stylist and art director for stills and television commercials, and established the television production company, The Film Business; Sydney's first small boutique hotel, The Russell; and The Bathers Pavilion restaurant and café in Balmoral. Victoria has also completed a Bachelor of Fine Arts (Hons) at the National Art School and is a children's guide at the Art Gallery of NSW. A home-making consultant and passionate traveller, *Colour* is her third book. She is also the author of *The Bathers Pavilion Cookbook* and *One*. www.victoriaalexander.com.au

Bibliography

Josef Albers, *Interaction of Color,* Yale University Press, New Haven, MA, 1975.

Luciana Boccardi, *Colors: Symbols, History, Correlations,* Marsilio, Milan, 2009.

Manlio Brusatin, *A History of Colors,* Shambhala, Boston, MA, 1991.

Francois Delamare and Bernard Guineau, *Colour: Making and Using Dyes and Pigments,* New Horizons, Thames & Hudson, London, 2002.

Victoria Finlay, *Colour,* Sceptre, London, 2002.

John Gage, *Colour and Meaning: Art, Science and Symbolism,* Thames & Hudson, London, 2006.

Johann Wolfgang von Goethe, *Theory of Colours,* The MIT Press, Cambridge, MA, 1970.

Bill Laws, *Fifty Plants That Changed the Course of History,* Allen & Unwin, Sydney, 2010.

Jill Morton, *Global Color: Clues and Taboos,* Colorcom, Honolulu, 2004.

Anne Varichon, *Colors: What They Mean and How to Make Them,* Abrams, New York, 2006.

Acknowledgments

This book is dedicated to Phoebe, Em and Will who, from the moment of
their births, have added colour and meaning to my life.

Apart from encouraging you to see with sharpened eyes, *Colour* speaks
to the similarities of the human spirit in all of us. We all have our own
colouring; we walk, talk, eat, laugh and cry. It also celebrates the delight
of travel. In the wise words of Mark Twain: 'Travel is fatal to prejudice,
bigotry, and narrow-mindedness.' The photographs were taken in
India, Vietnam, Laos, China, Iran, Syria, Ethiopia, Spain, France and
Australia. Almost all with a Canon Eos 5D Mark II.

Without the kind souls who allowed me to photograph them, this book
could not have happened. I thank them all, especially those with whom
I had no language in common. They understood my action to be one
of mutual respect, and offered me the possibility of capturing a little of
themselves. Some had never seen themselves in a photograph before.

Durga (Singh) in India and Ehob (Awraris) in Ethiopia enthusiastically
shared their knowledge, wisdom and passion for their customs and
countries, and led me on journeys of discovery. These travel experiences
are treasured times, ones I feel privileged to have had. I acknowledge their
kindness with much gratitude.

Murdoch's involvement began with a belief by M-J (Mary-Jayne House
in Marketing) who handed my manuscript to a then brand new publisher
Tracy (Lines). Tracy's words 'I'm excited by it' are some of the best I've
ever heard. I doubt it's possible to be given more support, belief or have
a finer eye to work with. Sarah (Baker) delighted me during editing
by telling me *Colour* encouraged her to play with her house. A huge
compliment to any manuscript. Thankfully she was also kind to my words.
Claire (Grady) played a central role and graciously managed us all with
warmth. Monique (Lovering) had the task of interpreting my vision. This
she did in an admirable, gentle and caring way. We 'got each other' and
I'm appreciative of the way she made me feel; there was never any your
idea or mine.

Then there's you, dear reader, without whom there would be no need
for such a wonderful and special collaborative time working together.
I thank you all. Very much.

Published in 2012 by Murdoch Books, an imprint of Allen & Unwin

Murdoch Books Australia
83 Alexander Street
Crows Nest NSW 2065
Phone: +61 (0) 2 8425 0100
Fax: +61 (0) 2 9906 2218
www.murdochbooks.com.au
info@murdochbooks.com.au

Murdoch Books UK
Erico House, 6th Floor
93–99 Upper Richmond Road
Putney, London SW15 2TG
Phone: +44 (0) 20 8785 5995
Fax: +44 (0) 20 8785 5985
www.murdochbooks.co.uk
info@murdochbooks.co.uk

For Corporate Orders & Custom Publishing contact Noel Hammond,
National Business Development Manager, Murdoch Books Australia

Publisher: Tracy Lines
Designer: Monique Lovering
Project Manager: Claire Grady
Editor: Sarah Baker
Production Manager: Karen Small

A cataloguing-in-publication entry is available from the catalogue of the
National Library of Australia at www.nla.gov.au.

A catalogue record for this book is available from the British Library.

Printed by 1010 Printing International Limited, China.
Reprinted 2013.